CHICAGO SLUGGERS

THE FIRST 75 YEARS

John Freyer and Mark Rucker

ARCADIA

D1314669

First published 2005

Published by Arcadia Publishing,
Charleston SC, Chicago IL, Portsmouth NH, San Francisco CA

Printed in Great Britain

Library of Congress Catalog Card Number: 2005922469

For all general information, contact Arcadia Publishing:
Telephone 843-853-2070
Fax 843-853-0044
E-mail sales@arcadiapublishing.com
For customer service and orders:
Toll-free 1-888-313-2665

Visit us on the Internet at www.arcadiapublishing.com

CONTENTS

INTRODUCTION &
ACKNOWLEDGMENTS

The purpose of this book is to bring to light hidden superstars of the not-so-distant past. Players like Ernie Banks and Ron Santo, Richie Allen and Luis Aparicio, are still fresh in our minds from our youths. But what about before their time? The 1940s and '50s? Back further … the '20s and '30s, the Teens, the 1800s? Who played right field 80 years ago in Wrigley Field?

Thanks to the beautiful baseball images of Mark Rucker and his company Transcendental Graphics (ruckerarchive.com) I can put to words a story for each man, who at one point in his career was tearing the ivy off the wall, or banging them off the center field wall at Old Comiskey; even if only for a season of two, he was the toast of the town.

I'd like to thank Mark Rucker for choosing me for such a project. This book and our next, *Chicago Aces* (about pitchers of the same eras as this book), have given me a fresh look at Chicago baseball, discovering some things that I didn't know existed; how good the Cubs of the early 1900s were; and the teams of the later '20s and early '30s; who the Hitless Wonders were; what about the solid Sox teams of the '30s and '40s? Rajah, Hack, Shoeless Joe, Old Aches and Pains, The Mad Russian, The People's Cherce…. Who were these men? Finding out is a gift of knowledge that I will cherish for the rest of my days.

I'd also like to thank Arcadia's Jeff Ruetsche, for gently prodding me and giving me pointers.

And mostly Art Ahrens, and Mike and Katie at Home Tavern, a long foul ball from Wrigley Field on Lincoln Avenue in Chicago's Lake View neighborhood, for letting me pick Art's mind, a few hours at a time. From the day I met Art, I was amazed by his mental recall of facts, particularly his knowledge of Cubs' history. He added colorful anecdotes about the ballplayers and scandalous details of their lives. Art is a true Chicago baseball historian. The stats speak for themselves in this book; the best stories are thanks to Art.

And my wife Carrie and my son Jack, who also sit and listen to my stories *ad nauseum*, about baseball ghosts of the past.

Dead tree references :
The McMillan Company. *The Baseball Encyclopedia Centennial Edition.* Collier-Macmillan, Toronto, Ontario, Canada, 1969
Freyer, John and Rucker, Mark. *19th Century Base Ball in Chicago.* Arcadia Publishing, Charleston, North Carolina, 2002
Lester, Larry, Miller, Sammy, and Clark, Dick. *Black Baseball in Chicago.* Arcadia Publishing Charleston, North Carolina, 2000
Putnam Books. *The Cubs.* Putnam Books, New York, NY, 1945

On-line research:
www.basebll-reference.com
www.baseballhistory.com
www.sabr.org (Society for American Baseball Research)
www.vintageballist.com
www.ruckerarchive.com

–John Freyer, Jan. 2005

1876–1899

The National League was formed in 1876 by the owner of Chicago White Stockings club, William Hulbert. Hulbert was tired of the teams in New York, Boston, and Philadelphia having control of the professional National Association, which was formed in 1871. The East Coast teams kept all the best players to themselves, keeping the top baseball talent away from cities in the Midwest. Hulbert invited the Midwest team owners to join him in starting a rival organization, and once they were onboard, he hand chose the other cities to join the National League.

Before this all took place, Hulbert took the liberty of signing arguably the best player in the league at that time, Al Spalding of the champion Boston Red Stockings, and sent Spalding back East to recruit some of his teammates. Spalding did just that. He brought Cal McVey, Deacon White, and Ross Barnes—all great hitters—back with him from Boston. Spalding also coaxed Hulbert's hand-picked man, superstar Cap Anson, to come along as well from the Philadelphia Athletics. The first "manufactured" champion was born.

The 1876 White Stockings stood atop the standings with a 52-14 mark. Ross Barnes led the league in hitting with a stellar .429 average. Cap Anson (.356), John Peters (.351), and Cal McVey (.347), finished third, fourth, and fifth for the league batting title that season. Even their star pitcher, Spalding, who pitched almost every game (61), batted .311 that season. He retired from pitching after the season, and by 1878, only Anson remained from the 1876 club.

The White Stockings of the 1880s were the first real dynasty of baseball, winning five championships in a seven year span. Cap Anson took over managing the team in 1879 and promptly led them to a first place finish in 1880 with a 67-17 record. Chicago outfielder George Gore led the league in hitting with a .360 mark. The White Stockings had four hitters in the top five in the league; besides Gore, was Anson in second (.337), Abner Dalrymple in fourth (.330), and Tommy Burns in fifth (.309). In 1881, the White Stockings repeated the feat with a 56-28 record. Anson led the league in hitting with a .399 mark. In a tight race in 1882, the White Stockings beat the Providence team by three games, giving them back-to-back-to-back championships. The team ended with a 55-29 record. Anson finished second in hitting with a .362 average. After the Boston Beaneaters won in 1883 and the Providence Greys did the same in 1884, the White Stockings were on top of their game again in 1885, winning the pennant with an 87-25 record. George Gore led Chicago in hitting (.313), and was fifth best in the league. Chicago finished its championship run in 1886, going 90-34 for the season. King Kelly (career-high .388) and Anson (.371) finished one-two in hitting for the year.

King Kelly was sold after the 1886 season and the championship run quickly disappeared. The White Stockings were disassembled when the rogue Player's League came into existence in 1890. Only Anson, Tommy Burns, and pitcher Bill Hutchinson stayed with the ball club. All others jumped to the Chicago Pirates of the Player's League, which lasted one season. The young replacements garnered a new nickname for the team in the media, the Colts, because of their young ages, and never finished higher than the second division for the next few years.

After the 1897 season, Anson was not retained by the ball club, with Tommy Burns taking over the helm. The team was then dubbed the Orphans because they lost their "Pop." Pop Anson, which was his nickname at the time, was 47 years of age when he hung up the spikes.

Adrian Constantine "Cap" Anson
Career 1871–1897 Chicago 1876–1897

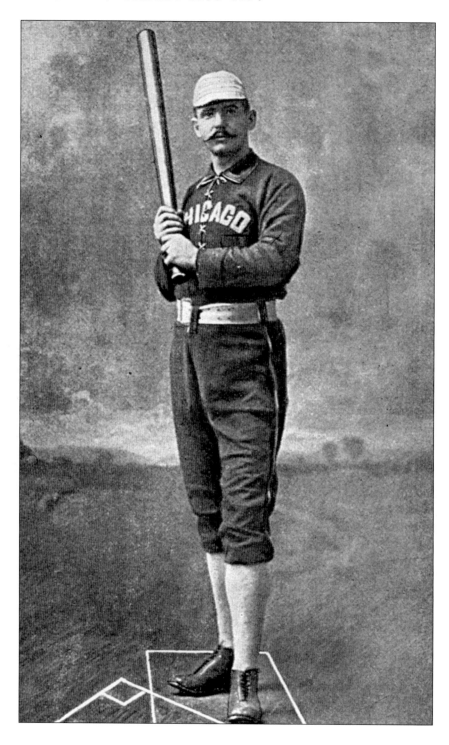

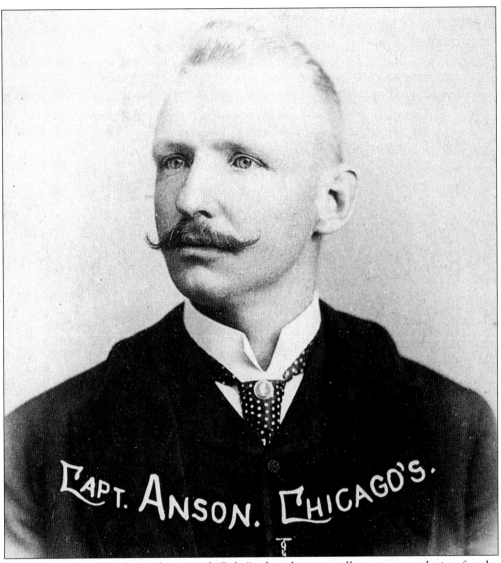

Capt. Anson. Chicago's.

Cap Anson went by the nickname of "Baby" when he was still a teenager playing for the Marshalltown, Iowa team with his father Hank and his older brother, Sturgis. After a year at Notre Dame, Anson tuned pro in 1871 with the Forest City Club of Rockford. The club folded that year and Anson moved on to play for the Philadelphia Athletics of the old National Association, the professional league (1871–1875) that predated the National League (1876). He later went on to become known as "Cap," during his peak ball playing years (1871–1890) and then "Pop" in the 1890s, when he was in his forties and still playing and managing the White Stockings. "Anse"—another of his many nicknames—led the league in RBIs with 82 in 1881, 147 in 1886, 84 in 1888, and 120 in 1891. The great Anson led the league in hitting with a .399 mark in 1881, a .344 average in 1888, and by hitting .388 in 1894 at the age of 42. Anson was also a fine manager. He managed the Chicago club from 1879 to 1897. Besides winning the championship in 1876 as a player, Anson managed White Stockings champions in the years of 1880, 1881, 1882, 1885, and 1886. Combined with his stats from his National Association years, Cap Anson was the first professional player with more than 3,000 hits in his career. He was an inaugural member of the Hall of Fame in 1939.

ROSCOE CONKLING "ROSS" BARNES

CAREER 1871–1881 CHICAGO 1876–1877

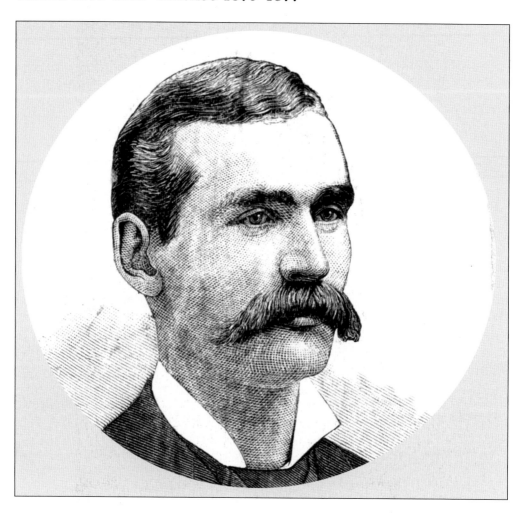

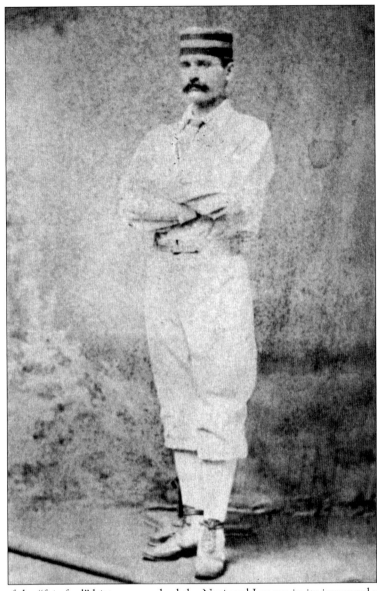

Barnes, last of the "fair-foul" hitters, scorched the National League in its inaugural year of 1876 with a league-leading .429 average. He was the master of the fair-foul hit, a ball that hits fair then goes foul (before the first or third base). Such a hit today would be a foul ball. Back then, it was a hit that had almost no way of defending against it. Most players "struck short," lightly tapping the ball fair before it rolled foul, similar to today's bunt. What made the play hard to defend was the fact that first basemen wore no gloves, so throws to first would have to be made right on the money, or the ball would sail into right field, gaining extra bases for the batter. The fair-foul rule was abolished after the 1876 season, and Barnes' average plummeted. He took up as a player-manager for Tecumseh Base Ball Club of London, Ontario, in 1878, and was out of baseball soon thereafter. Ross Barnes was also a baseball pioneer playing on the famous Forest City Club of Rockford with Albert Spalding and going on to play for the Boston Red Stockings, when the Forest City club disbanded in 1871. He became ill after the 1876 season and never played the same; while others blame it on the absence of the fair-foul rule.

George "Piano Legs" Gore
Career 1879–1892 Chicago 1879–1886

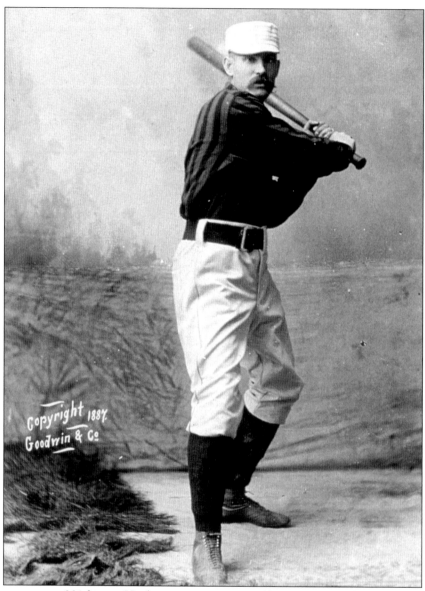

Gore was a career .301 hitter. His best years came in a Chicago National League uniform—leading the league at a .360 clip in 1880 and then posting five successive .300 plus seasons from 1882 to 1886 (.319, .334, .318, .313, and .304). A member of all five championship White Stockings clubs of the 1890s, Gore became a run scoring machine. He led the league in runs scored twice (1881 and 1882), scored 100 plus seven times, and, with a lifetime 1,327 runs scored in 1,310 games, is one of the few long-term major league players in history to score more runs than games played. He earned his nickname for his large calf muscles, which must have helped him on the base paths. Gore stole seven bases in a single game in 1881—a major league record. He finished his career in New York and St. Louis before retiring after the 1892 season.

Frank Sylvester "Silver" Flint
Career 1878–1889 Chicago 1879–1889

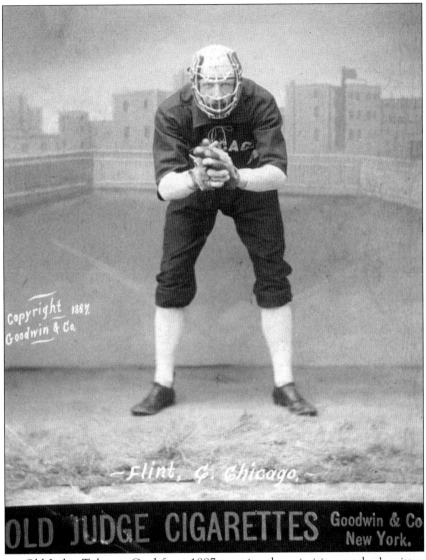

Copyright 1887.
Goodwin & Co.

– Flint, C. Chicago. –

OLD JUDGE CIGARETTES Goodwin & Co
New York.

This is an Old Judge Tobacco Card from 1887—notice the primitive catcher's mitt and face guard. Silver was named as such because of his light blond hair. Flint was a career .239 hitter and played on all five of the White Stocking championship teams of the 1880s. His best year was in 1881 when he hit .310. Flint was a classic example of the hard-nosed ballplayer of that era. He began playing in the days before equipment, when no gloves or masks were used. He continued to play barehanded for much of his career, until injuries to his hands and face made it necessary to wear a glove. It is reported that Flint broke every bone in his face and hands during his career. The *New York Clipper* is quoted as saying, "He has few equals and no superiors as a hardworking and effective catcher, facing pluckily the swiftest and wildest pitching, being an accurate thrower to all bases." I guess it could also be said that Flint had a face that could stop a fastball.

EDWARD NAGLE "NED" WILLIAMSON
CAREER 1878–1890 CHICAGO 1879–1890

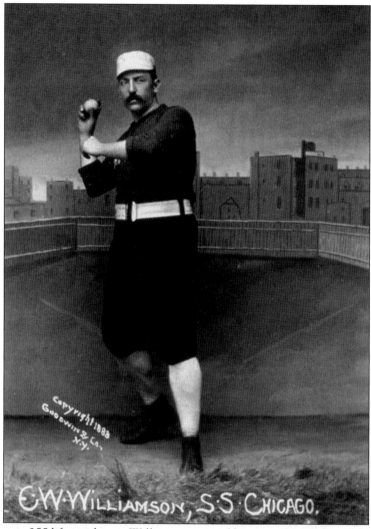

Ned was a hearty .255 lifetime hitter. Williamson rotated between shortstop and third base with Tommy Burns for several years, based on Anson's hunch of who will have a better day fielding. Ned played on all five of Anson's champion teams of the 1880s. For the 1884 season, the White Stockings changed the ground rules at cozy Lakefront Park (196 feet to left, 210 to right), which was located where Randolph Street now meets the lake in downtown Chicago. The old ground rule was that balls hit over the short fence were considered doubles. With that rule in place in 1883, Williamson hit 49 doubles. In 1884, it was considered a home run for the first and only time. Williamson went on to hit 27 home runs that year. It was a record that lasted through the "deadball" era and was broken by a young man named Babe Ruth, who hit 29 in 1919. Ned broke his leg in Egypt on the White Stockings World Tour in 1888 and was never the same afterwards, catching an infection with inadequate medical care around, which weakened his once-strong physical structure. Anson called Williamson "the best all-around ball player" he ever saw.

14

MICHAEL JOSEPH "KING" KELLY
CAREER 1878–1893 CHICAGO 1880–1886

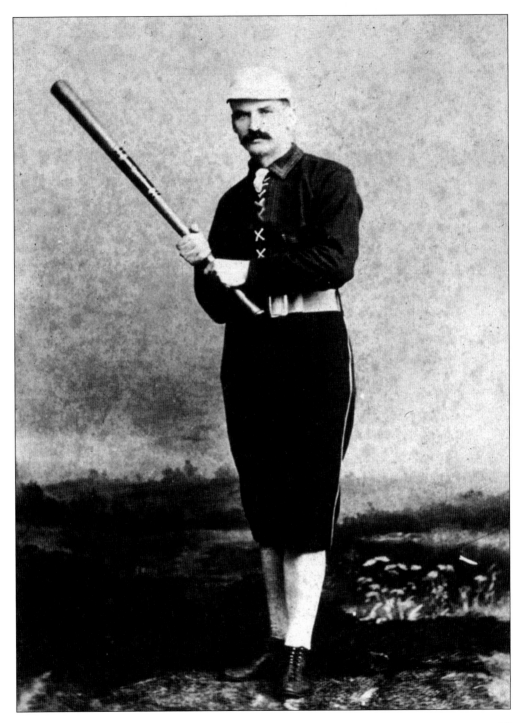

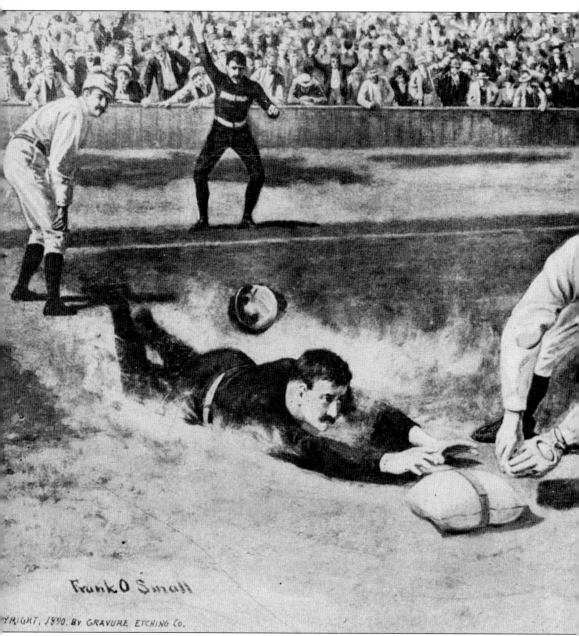

Frank O Smith

This is the famous lithograph, "Slide Kelly Slide," of the infamous King Kelly. In 1886, his last as a White Stocking, Kelly hit .388, scored 155 runs in 124 games, stole 53 bases and played all eight fielding positions over the course of the season. He also led the league in 1884 with a .354 average and 120 runs scored. King Kelly was a multi-talented ball player and a notorious cheater. He was known for stealing third base from first while the umpire wasn't looking. Or he would cut across the field while scoring from second base, never getting close to touching third. He said it was to save time. Kelly always wanted more money. He helped negotiate his own sale to Boston after the 1886 season, of course, and he wanted his cut of the sales price of $10,000. Kelly got half. For this he became known as the "The "$10,000 Kelly." He also played in the National Association, coaching and playing for the Cincinnati Kellys. King Kelly won five

championships in his time in Chicago. A heavy drinker, Kelly toured the stage and vaudeville circuit reciting "Casey at the Bat" during the off-season. Kelly is also believed to be the first player to charge for use of his image. The always nattily-dressed Kelly was driven to the park in a majestic horse drawn carriage. Once, on a pop foul, Kelly announced himself into the game (which he wasn't playing), and caught the ball. Many of the major rule changes of that era were due to Kelly's blatant disregard toward the rules, including the use of two umpires on the field. His fast living and flamboyant lifestyle caught up with him when he passed in 1894 at the age of 36. King Kelley was inducted to the Hall of Fame in 1945.

Nathaniel Frederick "Fred" Pfeffer
Career 1882–1897 Chicago 1883–1897

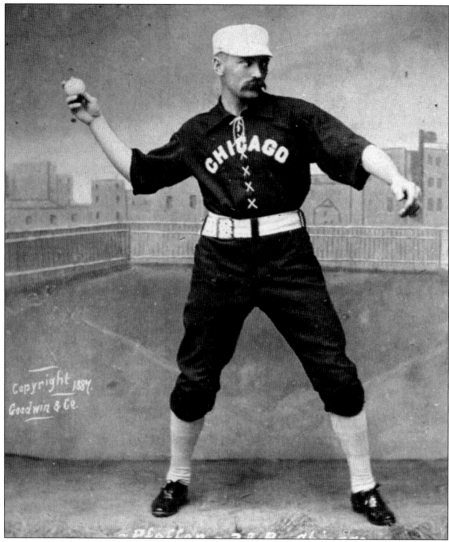

Pfeffer was nicknamed "Dandelion," due to his prowess at fielding "daisy pickers" and "dandelion killers" (hard ground balls) at second base. He played for the champion White Stockings teams in 1885 and '86. Pfeffer smacked 25 home runs in 1884 when Lakefront Park was home run friendly. Pfeffer also hit 16 home runs later in his career at the expansive West Side Grounds. His significant innovation for the game was to cut off a throw to second base on the double steal of home plate, returning the ball to home plate and getting out the potential scorer from third. Pfeffer also authored the *Scientific Ball*, which discussed the subtleties of the game of that period, and was one of the last ballplayers to not wear a glove. Even with this lack of equipment, Pfeffer was one of the league leaders in fielding, year in and year out.

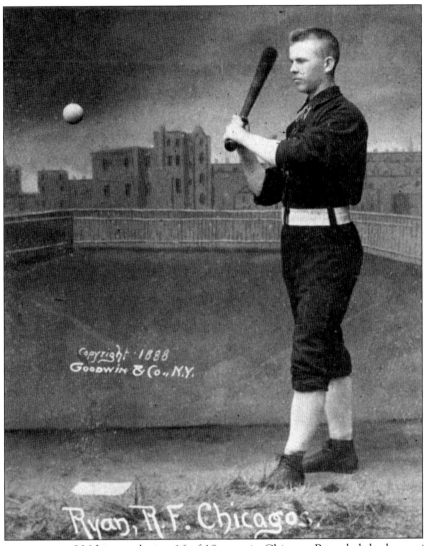

Copyright 1888
Goodwin & Co., N.Y.

Ryan, R.F. Chicago

Jimmy was a career .306 hitter, playing 16 of 18 years in Chicago. Ryan led the league in 1888 with 182 hits, 33 doubles, and 16 home runs. He also hit .332 that year with 64 RBIs. Ryan hit .361 in 1894. He played right field for the championship teams of 1885 and '86. Jimmy Ryan, not trusted by Anson after the Player's League mutiny of 1890, was considered the main reason why Anson was let go in 1898. Ryan had expected to take over the team, which went to Anson protégé Tommy Burns. Ryan then helped Burns get fired by staging a sit down strike before the start of the season. Burns lost all control of the players soon after that. Ryan wasn't very well liked. Some say he conspired with then Chicago President James Hart to oust Anson for his own personal gain. Ryan once also beat up a sportswriter. After his retirement in 1904, Jimmy became a cop and played semi-pro ball in Chicago's far north neighborhood of Rogers Park. Some baseball historians consider that he should be in the Hall of Fame with the solid career numbers that he put together in the late 1880s.

Hugh Duffy
Career 1888–1906 Chicago 1888–1890

Hugh Duffy was a career .324 hitter. Duffy led the Players League in 1890 with 191 hits and 161 runs scored for the Chicago Pirates. He also stole 78 bases and hit .320 that season. He went on to star for the Boston Beaneaters in the 1890s. Duffy hit .440 in 1894. He managed the White Sox in 1910 and 1911, and later in his career, as a Red Sox coach, Duffy was a tutor to a young Ted Williams. Duffy had a short career in Chicago, mostly due to the fact he was a hard drinker, for which Anson had no tolerance. Anson also had much animosity toward Irishman, feeling that they were a bunch of irresponsible drunks, so he placed heavy fines on Duffy and catcher Malachi Kittredge, who always seemed to draw the brunt of Anson's ire. Duffy was inducted to the Hall of Fame in 1945.

GEORGE VAN HALTREN
CAREER 1887–1903 CHICAGO 1887–1889

George Van Haltren started as a pitcher for Cap Anson's Colts. After walking 16 batters in one game in 1887, Anson started playing the rookie in the outfield. While a good pitcher (24-20 with 215 strikeouts through 1887–1888), Van Haltren really stood out as a leadoff hitter. He became a career .316 hitter with 583 stolen bases. He hit .309 for Anson's club in 1889, with 82 walks and 28 steals, his first season as fulltime position player. After that, George moved around from the upstart Players League, to the American Association, and back to the National League with Pittsburgh before landing in the Polo Grounds in 1894. He starred for the New York Giants into the early twentieth century. His best season was 1896, with a .351 batting average and a league-leading 21 triples. The speedy Van Haltren suffered an ankle injury that forced him from the majors, and he finished out his baseball playing days in the Pacific Coast League from 1904 to 1909.

WILLIAM FREDERICK (BILL) DAHLEN
CAREER 1891–1911 CHICAGO 1891–1898

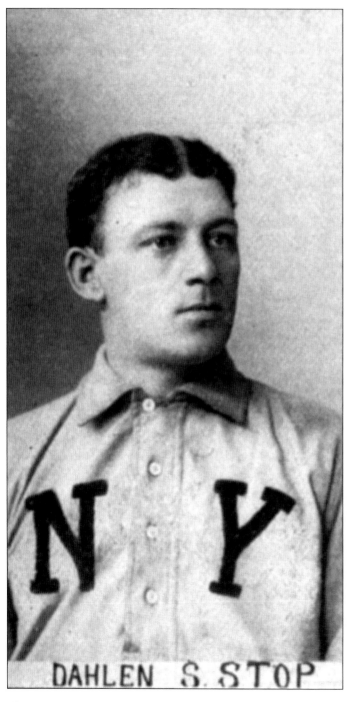

DAHLEN S. STOP

"Bad Bill" was a career .277 hitter. Dahlen had a huge season for the Colts in 1894. He hit .357 with 32 doubles, 14 triples, 15 home runs, and 107 RBIs. He also stole 42 bases. Two years later, he hit .352 for the Cubs with 19 triples. Dahlen was also a speed merchant. He had a career high in stolen bases with 60 in 1892. Dahlen holds the National League record of 7,500 shortstop assists and the Major League record of 13,325 chances. Because of the sheer number of chances he had over his career, and the small gloves of the era, Dahlen also holds the record for 972 errors at shortstop, which because of modern game equipment will never be broken. His 20 years as a shortstop is also a National League record. Dahlen had a 42-game hitting streak in 1894 that was the longest streak of his day, until Wee Willie Keeler broke it with 44 in 1897. After a brief stint with the Brooklyn Dodgers, Dahlen was the shortstop for McGraw's Champion New York Giant teams of the early 1900s, which fought the Cubs for first place through the first few years of the twentieth century.

Two
1900–1919

In 1900, Ban Johnson decided to change the name of the existing minor league Western Association to the American League, placing teams in stalwart National League cities like Chicago, St. Louis, Cleveland, New York, and Boston. The Chicago franchise in 1900 was considered a minor league team, being a remnant of the St. Paul Saints of the Western Association.

In 1901, the American League was recognized as a major league. By 1903, the two leagues decided to show off their best teams in October by playing each other. This practice had existed since the 1880s, like the Temple Cup, one league's best against the other's, but it never took on the grand scale of what would become the World Series.

That season the White Sox took the first American League pennant, led by manager-pitcher Clark Griffith (24 wins, 7 loses). The Sox finished with an 83-53 record, four games ahead of the Boston Red Sox. Fielder Jones led the team with .311 average followed by third baseman's Dutch Hartman's .309 average.

The Cubs and Sox met in the World Series for the only time in their history in 1906. The Cubs were the best team in baseball with a 116-36 record, still the best ever. Cubs third baseman Harry Steinfeldt led the National League with 86 RBIs. Pitcher Mordecai Brown (25 wins, 6 losses) led the league in ERA (1.04). Shortstop Joe Tinker, Harry Steinfeldt, and catcher Johnny Kling also led the league in fielding at their respective positions. The Sox were a light-hitting team (.230) with great pitchers and stellar defense. The Sox were led in hitting by first baseman Frank Isbell (.279) and Hall of Fame shortstop George Davis (.277). Doc White (18 wins, 6 losses) led the American League in ERA (1.52). Center fielder Fielder Jones, first baseman Jiggs Donahue, and catcher Billy Sullivan led the league in fielding at their positions. The White Sox won the Series, four games to two. The Sox hit a slim .198, besting the Cubs, who were stymied by the Sox pitchers, hitting .196.

Though the Cubs lost the Series, they would go on to win the National League Pennant in three of the next four years. These teams were led by the Hall of Fame infield combination of Joe Tinker, Johnny Evers, and Frank Chance. The pitching staff was led by "Three Finger" Mordecai Brown.

The ball game back then was still very different to the baseball we know today. Equipment was still being developed. Mitts were a little larger than a man's hand. The balls were "dead." Even in cozy ballparks like the Polo Grounds, few home runs were hit. Triples of that time were just as good as homers. Teams used speed and savvy to gain advantage of their opponents. The Cubs were masters of this style, built around speed and defense.

In 1907 and 1908, the Cubs faced Ty Cobb's Detroit Tigers. In the 1907 Series, behind stellar pitching performances, the Cubs swept the Tigers four games to none, with the Tigers scoring a grand total of three runs for the whole Series. The following October, the Cubs repeated their dominance over the Tigers with a four to one Series win.

In 1910, the Cubs sluggers were held to a .222 average by the Philadelphia A's. Jack Coombs and Chief Bender pitched the A's to a four games to one Series win.

The White Sox bought Joe Jackson and Eddie Collins in the middle years of the Teens, and soon after the Sox were in the World Series. The 1917 White Sox went 100-54 under coach

Pants Rowland. The team was led by Happy Felsch (.308, 102 RBIs) and Shoeless Joe Jackson (.301 BA). Pitcher Eddie Cicotte won 28 games, leading the American League. The Sox beat the New York Giants in the World Series that year four games to two, led by Urban Faber's three wins. Eddie Collins hit .409 for the Series.

The 1918 Cubs jumped from fifth place in 1917, to first. The team was lead by enigmatic shortstop Charlie Hollocher (.317 BA), who's career was cut short due to being a hypochondriac, and Fred Merkle (.297 BA), the same Fred Merkle of the "Merkle's Boner" for the Giants in 1908. The team won 84 games and lost 45. Pitcher Hippo Vaughn won a league-high 22 games and led the league in ERA (1.74). The Cubs lost the Series to the Boston Red Sox, four games to two, over powered by a young pitcher named Babe Ruth. Ruth went 2-0 with a 1.06 ERA in the Series. It was a pitcher's Series with the Cubs scoring ten runs in six Series games. Boston tallied nine runs in the Series.

In 1919, Kid Gleason led the White Sox to an 88-52 record, leading them to a three and a half-game lead over the Cleveland Indians. The 1919 team is best known as the "Black Sox," the only players to throw a World Series (and get caught) in the history of the game. Led by Joe Jackson and Hall of Famer Eddie Collins, the Series was lost five games to three to the underdog Cincinnati Reds. Though Jackson (.375 BA) and Buck Weaver (.324 BA) played well in the Series, they took the collar with the rest of their teammates that conspired with Chick Gandil and the underworld to blow the Series. A total of eight players were suspended after the 1920 season, including Jackson, Weaver, Gandil, Happy Felsch, and Eddie Cicotte. It would be forty years before another White Sox team got to a World Series.

From 1914 to 1915, the short-lived Federal League's Chicago Whales entertained the Lake View neighborhood at cozy Weeghman Park, at Addison and Clark Streets—1060 West Addison, to be exact. If the address sounds familiar, it should. That's Wrigley Field these days. The Whales, under manager Joe Tinker, finished second behind the Indianapolis team by one and a half games, posting an 87-67 record. Pitcher Claude Hendrix finished 29–11 with a 1.69 ERA. Former Sox player Dutch Zwilling led the Whales with a .313 average and 15 home runs along with 95 RBIs.

The Whales finished first in 1915 with a 86-66 mark. Pitcher George McConnell went 24-10 with a 2.20 ERA to lead the staff. Dutch Zwilling led the batters with a .287 BA, 13 homers and a league-leading 94 RBIs. Just before the start of the 1916 season, the league folded. The better players ended up on the Cubs or Sox.

WILLIAM ELLSWORTH "DUMMY" HOY
CAREER 1888–1902 CHICAGO 1900

Hoy was a .287 lifetime hitter. "Dummy" was given his name due to the fact he was a deaf and dumb mute, due to childhood meningitis. Hoy played on the White Sox original team in 1901. He hit .294 that year, drawing 86 walks to lead the league. Hoy was only 5-foot-4 and described as "the smallest outfielder, ever," by players of his day. Dummy was also described as tough as nails, due to his physical afflictions. Hoy was also the reason that umpires developed hand signals. Dummy Hoy lived to be 99 years old. He threw out the first pitch of the third game of the 1961 World Series, being the oldest living ballplayer at the time. He died a few months later.

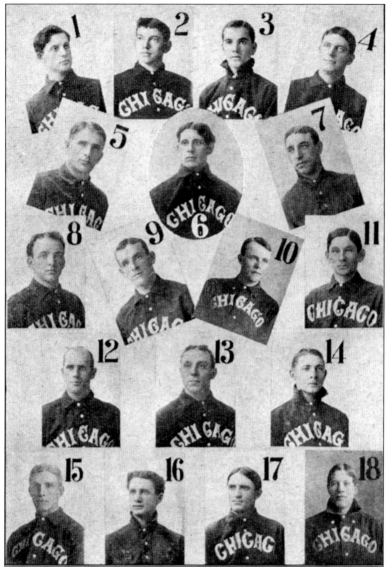

The 1906 White Sox were known as the "Hitless Wonders." They hit .230 as a team, yet figured out a way to win 93 games under player-manager Fielder Jones. The Cubs had the best record in baseball, under Frank Chance, with 116 wins and 36 losses. Their winning percentage (.763) is a record that still stands today. The 116 win totals have also stood the test of time, only matched by the 2001 Seattle Mariners, with ten more games played than the 1906 Cub team. The White Sox won the anemic hitting Series over the cross-town rival Chicago Cubs. The Sox hit a whopping .198 for the Series. The White Sox scored six runs in the first four games of the Series, yet were tied two games to two. The reason why? The Cubs hit .196 for the Series. The Sox scored sixteen runs in the final two games, winning the Series four games to two. The following are the batting averages and positions of the World Champion Chicago White Sox of 1906: 1B, Donahue (.257); 2B, Isbell (.279—led the team); SS, Davis (.277); 3B, Tannehill (.183); RF, O'Neill (248); F. Jones (.230); CF, Hahn (.227); C, Sullivan (.214). The reason for the success was their pitching. Their 2.13 team ERA was second in the American League behind Cy Young's Cleveland team.

GEORGE STACY DAVIS
CAREER 1890–1909 CHICAGO 1902, 1904–1909

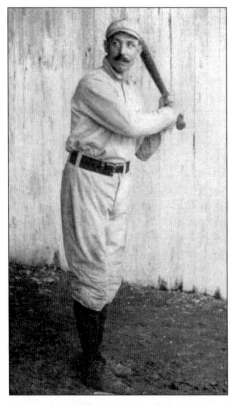

Davis was a career .294 hitter who played on the 1906 Hitless Wonders World Series team. Earlier in his career, Davis was a star with the New York Giants in the 1890s. George Davis finished his 20-year career with the White Stockings. His best season for the Sox was 1904 when he hit .252 with 27 doubles and 15 triples. He hit .355 in 1893 for the New York Giants with 27 triples, 11 home runs and 119 RBIs. He also had 134 RBIs in 1897 for the Giants. Davis' standoffish attitude with management probably led to Davis' failing to gain acceptance in the Hall of Fame during his lifetime. In 1903, when the two leagues were warring, Davis turned down a Comiskey contract and jumped to the Giants of the NL. The NL President awarded Davis back to the Sox in 1904, but Davis had only average years with Sox after that. Some historians feel that it was Davis' animosity toward Comiskey that led to his less than stellar career with the White Sox. He was inducted to the Hall of Fame in 1998.

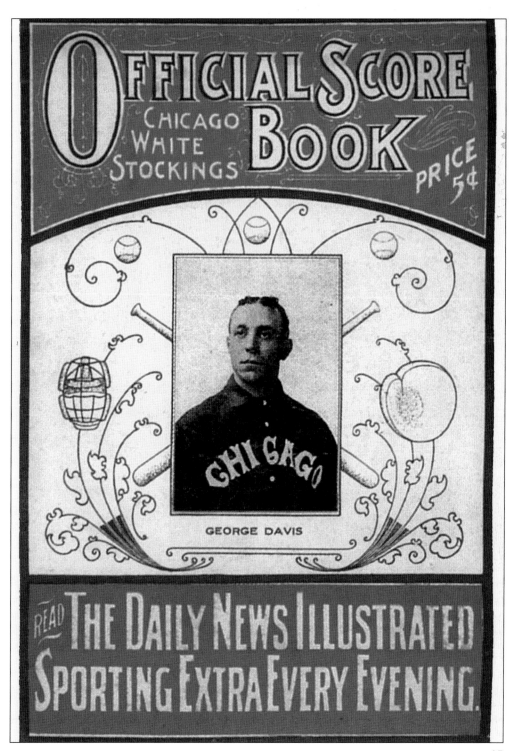

FIELDER ALLISON JONES
CAREER 1896–1915 CHICAGO 1901–1909

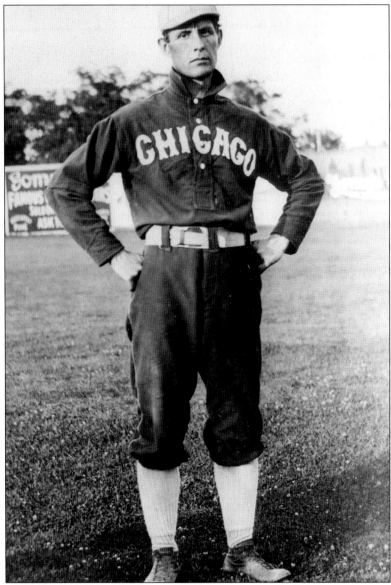

Jones was on the White Sox in their inaugural major league season of 1901, coming over from the National League's Brooklyn Dodgers. He was a career .284 hitter. In his first two seasons with the Sox, he hit .311 in 1901 and .321 in 1902. Jones also scored 120 runs in 1901. He was the player-manager for the 1906 Hitless Wonders, hitting a characteristic .230 for that season. He did have a career best 22 doubles for the 1906 Sox. Jones was also the first AL outfielder to make an unassisted double play. An innovator, he is credited for the "motion infield" and positioning hitters based on the batter. He was a stern task master, suspending players for drunkenness or bonehead plays, but often bore the brunt of dealing with Comiskey on behalf of his players, for which the players respected him.

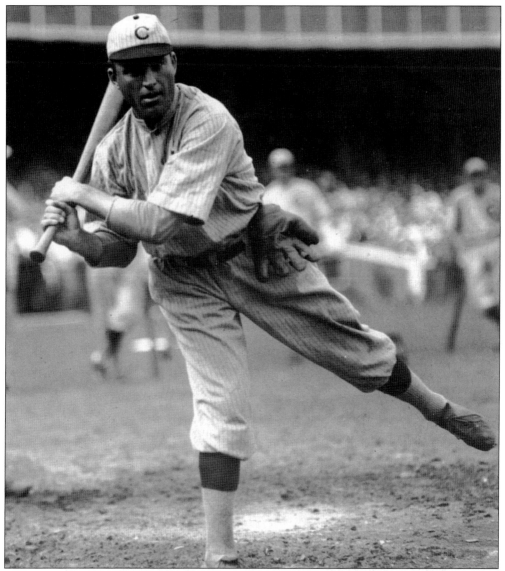

Jimmy Sheckard was a career .274 hitter. He played outfield for the Cubs pennant-winning teams in 1906, '07, '08, and '10. Sheckard's best season with the Cubs was 1911, when he scored 121 runs to lead the league and drew 147 walks, which also led the league that year. He batted .276 that season. He was one of a handful of Pennsylvania Dutch to ever play in the major leagues. Though mostly known for his time with the Champion Cubs, his best years were early in his career with Brooklyn. Sheckard hit .353 in 1903 with 29 doubles, 19 triples and 11 home runs, leading the league with a .534 Slugging Percentage. He also scored 116 runs while driving in 104 and stealing 35 bases. In 77 World Series at-bats for the Cubs, Jimmy hit an anemic .182. Sheckard embarrassed himself in the 1906 Series against the White Sox, bragging that he'd hit .400 for the Series. He went 0 for 21.

29

Frank Leroy Chance
Career 1898–1914 Chicago 1898–1912
Hall of Fame 1946

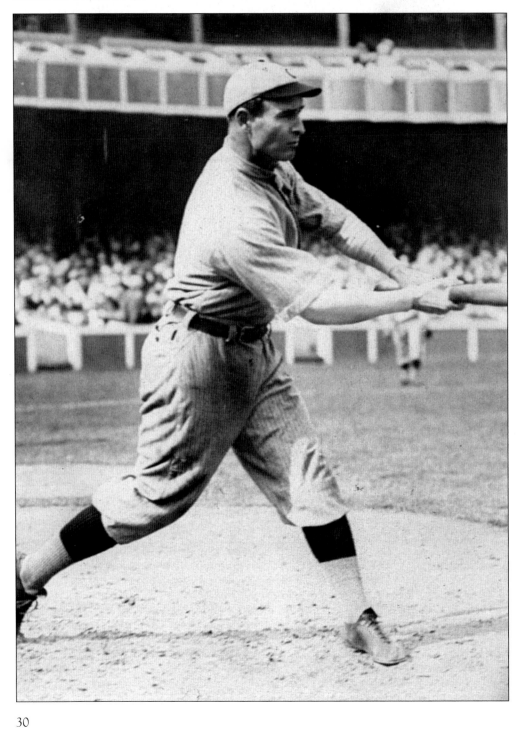

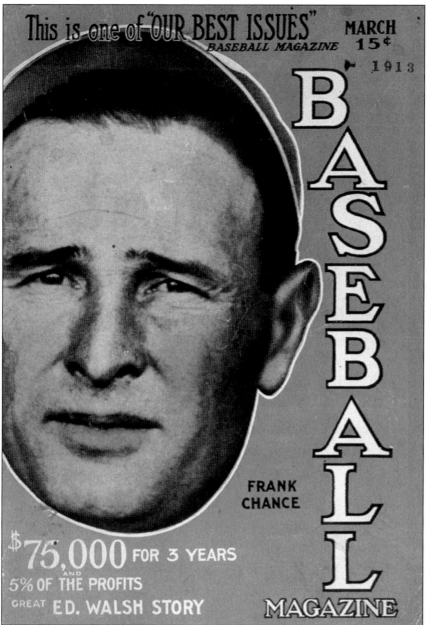

"Husk," or the "The Peerless Leader," Chance was a career .296 hitter. He led the league in RBIs in 1906 with 106. Chance was also fleet of foot for a first baseman, stealing 67 bases in 1903 and 57 in 1906. Husk was the cornerstone of the famous Tinker-to-Evers-to-Chance double play combination. Chance played on and managed the Cubs to four World Series appearances (1906, 1907, 1908, and 1910), helping his own cause by hitting .421 in the 1908 World Series—the Cubs last championship. Called Husk due to his husky stature and the Peerless Leader because of his prowess as a manager, Chance ran his teams with a clenched fist. He never backed down from an argument and never backed away from the plate as a hitter. He was beaned several times because of his headstrong ways; hopefully, he also possessed a strong head. Chance said the beanings affected his hearing later in his career.

JOHN JOSEPH "JOHNNY" EVERS
CAREER 1902–1917, 1922, 1929 CHICAGO 1902–1913, 1922.

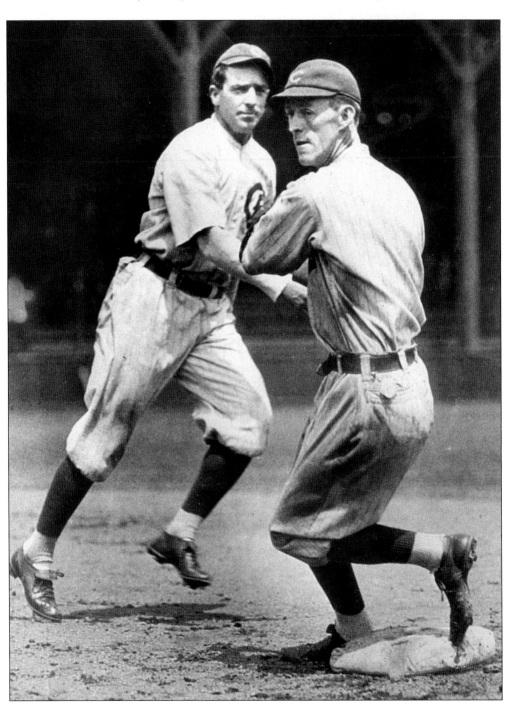

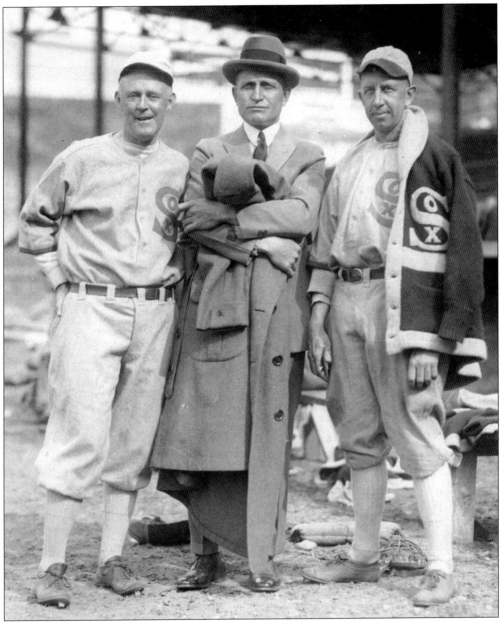

This rare picture shows Evers (left) in a White Sox uniform, where he was a coach later in his career. Evers was called the "The Trojan" because he was from Troy, New York, and "The Crab" for the way attacked ground balls from the side (not due to his demeanor). The Trojan was better known for his fielding than his hitting. He was a .270 lifetime hitter. Evers gained fame for being the middle of famous Tinker-to-Evers-to-Chance infield. Johnny played on four Cubs World Series teams (1906, 1907, 1908, and 1910). Evers career best was hitting .341 in 1912. He also stole 49 bases in 1906. In the last two World Series won by the Cubs (1907 and 1908), he hit .350. Evers knocked in the winning run in the 1908 World Series. He was inducted to the Hall of Fame in 1946.

This great period picture of Johnny Evers entertaining some of his many admirers

could be straight out the *Little Rascals*.

JOE TINKER
CAREER 1902–1916 CHICAGO 1902–1912, 1914–1916

The "Tinker" of the famous Tinker-to-Evers-to-Chance double play combination swings at the high pitch. Tinker and Evers couldn't stand to be with each other, both being fierce competitors and blaming the other when things went wrong. Joe Tinker once had an argument with Johnny Evers in 1905 over cab fare that spilled onto the field as a fist fight. They didn't speak to each other until the 1938 World

Series, when they were honored for their role as the last Cub champs of 1908. When Tinker and Evers saw each other that night, for the first time in more than 20 years, they hugged and cried on each other. Tinker was a .263 lifetime hitter, but was known as a slick fielder. He led shortstops in fielding four times. Joe was the shortstop for the Cubs pennant winners in 1906, 1907, 1908, and 1910. He was inducted to the Hall of Fame in 1946.

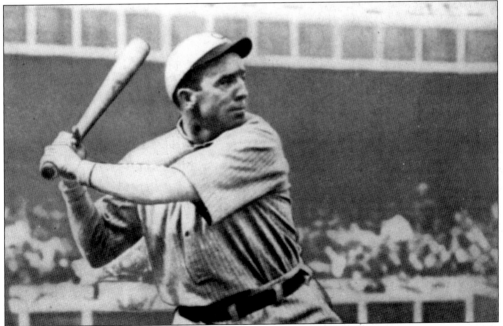

Tinker was traded to Cincinnati to fill the role of player-manager for the Reds in 1912. He refused to play in 1913 for the Reds, so they traded him to the Dodgers, for whom he also didn't want to play. He came back to Chicago as the player-manager for the Federal League's Chicago Whales, an upstart third league, which was short-lived in the Teens.

JOHN GRADWOHL "JOHNNY" KLING
CAREER 1900–1913 CHICAGO 1900–08, 1910–1911

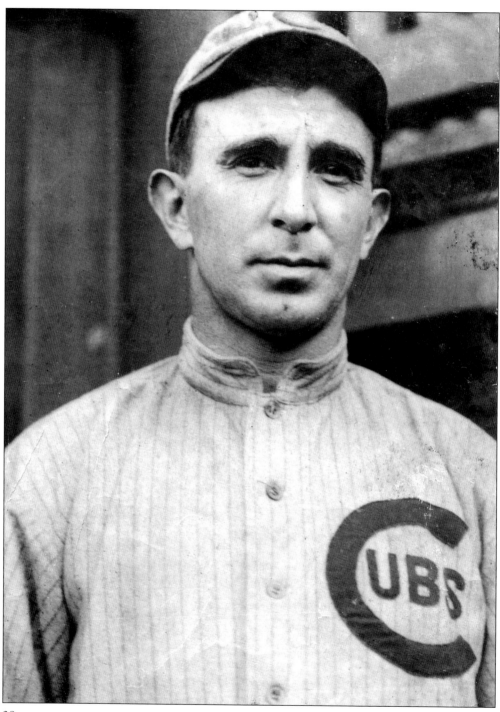

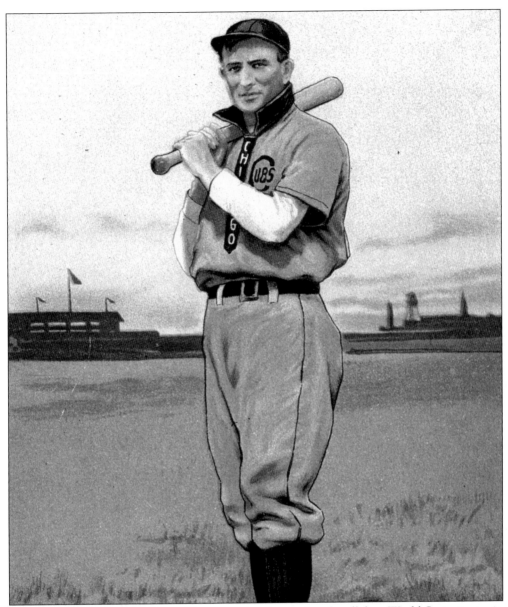

"Noisy" was a career .271 hitter. Kling was also the catcher for all four World Series teams in the early 1900s. He hit .312 in 1906. But his best offensive year was when he hit .297 with 29 doubles, 13 triples, and 68 RBIs in 1903. He was a multi-sport star—if you consider shootin' pool a sport. Kling owned his own pool hall in Kansas City. Because of this, he became an accomplished billiards player. He was so good that he won the world pocket billiards championship in the winter of 1908–09. Because he was making more money shooting pool than he did in baseball, he gave up ball for the 1909 season to pursue playing pool. That season he played on a semi-pro team in Chicago, which was almost as popular as the major league game; some teams were close to the Cubs and Sox in skill. He was ordered to play for the Cubs by the commissioner of the National League in 1910, and at his 1908 salary, because of besmirching the good name of baseball. The Cubs won the pennant in 1910, but Kling was out of town the following year.

Patrick Henry "Patsy" Dougherty
Career 1902–1911 Chicago 1906–1911

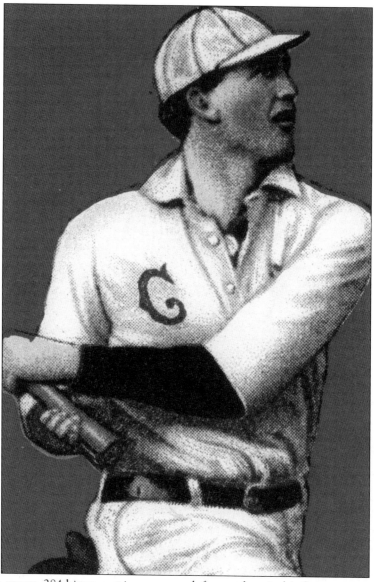

Patsy was a career .284 hitter, putting up some lofty numbers in his first two seasons with the Boston Red Sox and New York Highlanders (Yankees). Dougherty was the first player to hit two home runs in a World Series game (for the Boston Red Stockings in 1903). Patsy then played for the New York Highlanders until being released by them for beating up manager Clark Griffith. Fielder Jones had scouted Dougherty and grabbed him for the 1906 World Series run. Patsy started all six games in the World Series, hitting .100 for the Series. He was quick and mean. Patsy stole a league-leading 47 bases in 1908. Patsy's best season was 1909, hitting .285 with 23 doubles, 13 triples, and 71 RBIs. He was known as a brawler outside the ballpark, handling himself well in many a scrape.

William Frank "Frank" Isbell
Career 1998–1909 Chicago 1898, 1901–1909

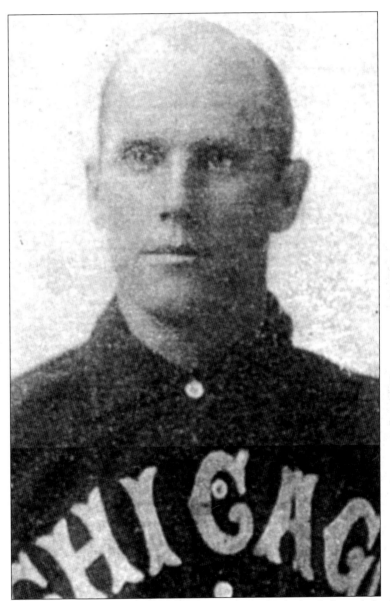

The "Bald Eagle" was the first of four ball players to play for both the Cubs and the Sox. Frank was out of major league baseball when called upon by the fledgling White Sox of the American League. Isbell lead the American League in 1901 in steals with 52. Isbell was a lifetime .250 hitter, but led the Hitless Wonders of 1906 with a .279 average while playing second base for the World Series Champs. Isbell helped pace the club with a .308 average in the Series that year. Frank's best season was 1905, hitting .296 with 21 doubles. Isbell is only one of a handful of players that played more than ten years and spent their whole career in Chicago, on both sides of town.

Solly Hofman
Career 1903–1916 Chicago 1904–1916

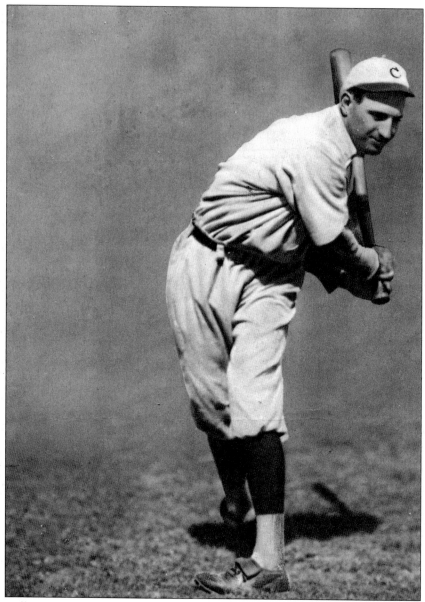

"Circus Solly" was a career .269 hitter. In his four World Series appearances for the Cubs, Solly hit .298. His best season was 1910 when he hit .325 and drove in 86 RBIs. He was called Circus Solly because of his antics in the clubhouse. Solly came to the Cubs from the Pittsburgh Pirates where had only played two games in 1903. He played seven games for the Cubs in 1904. Solly became a starter in 1907 and was in the outfield for the '07, '08, and '10 World Series teams. He was a role player for the '06 team. Circus Solly was traded in 1912 back to Pittsburgh and finished his career with Buffalo of the Federal League.

HARRY M. STEINFELDT
CAREER 1898–1911 CHICAGO 1906–1910.

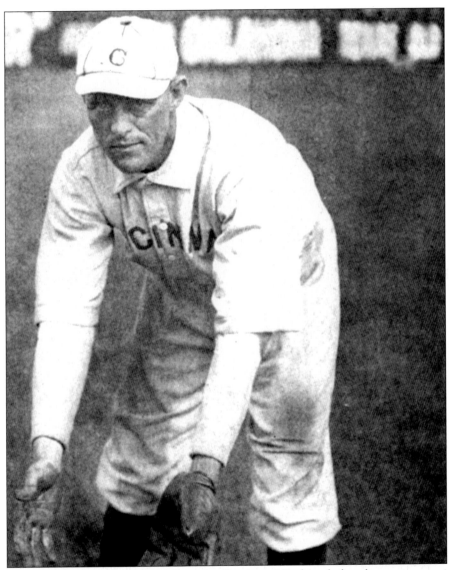

Steinfeldt came to Chicago in 1906 from the Cincinnati Reds and played on pennant winners four out of five of his seasons in Chicago. Some historians feel that more than anyone else on that team, Steinfeldt was the main reason for the Cubs success in this era. The Cubs went to the Series the first year he showed up (1906), and the last time that team reached the Series was Steinfeldt's final season with the club (1910). He had a .267 batting average, but was considered a real clutch hitter. Steinfeldt is the answer to the age-old trivia question: Who was the third baseman during the Tinker-to-Evers-to-Chance infield? Steinfeldt's 176 hits and 83 RBIs led the league in 1906, a season he hit .327. The following seasons, he never hit over. 267 or had more than 70 RBIs. Harry hit .260 in 73 World Series at-bats. This included a scorching .471 average in the 1907 Series, which the Cubs won over Detroit.

Frank "Wildfire" Schulte
Career 1904–1918 Chicago 1904–1916

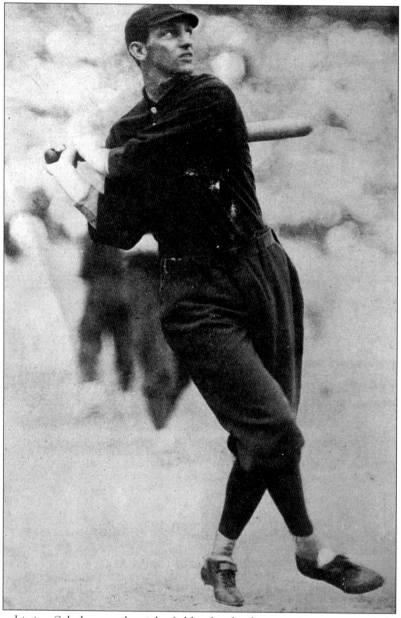

The heavy-hitting Schulte was the right fielder for the four pennant winning Cubs' teams of the early 1900s. Schulte was a career .270 hitter. In 1906, Wildfire hit .281 with 18 doubles, a league-leading 13 triples, 7 homers, and 60 RBIs. Schulte's best season was 1911, when he hit .300 with 30 doubles, 21 triples, 21 home runs, and 107 RBIs. Wildfire was a career .309 hitter in the World Series with 81 at-bats. He also held the record for most Grand Slams in a season with four in 1911. This record lasted into the 1950s until broken by Cub Ernie Banks.

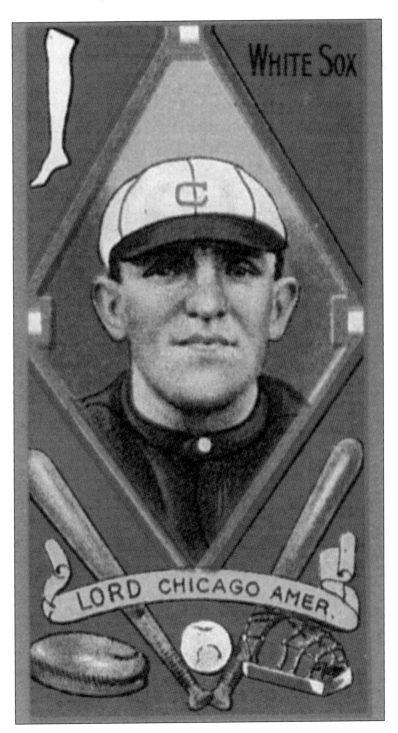

The enigmatic Lord was a career .278 career hitter. He hit .321 in 1911 with 18 double, 18 triples, and 103 runs scored. Harry Lord left the team during the 1914 season, for no other reason than having personal problems and losing his will to play. He was out of baseball after 1915, having played one more season as a player-manager for the Buffalo team of the Federal league. Lord was an immobile third baseman and was an inspiration as well as an enigma for his teammates.

Edward Trowbridge "Eddie" Collins
Career 1906–1930 Chicago 1915–1926

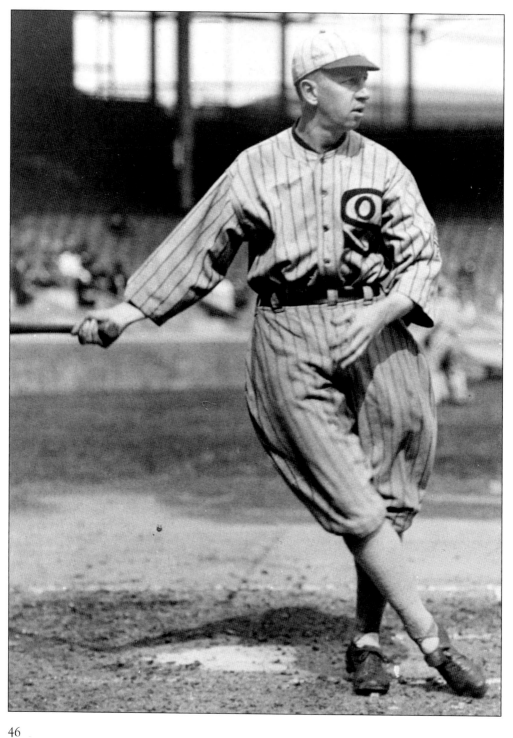

"Cocky" was a career .333 hitter. Collins played on the White Sox 1917 and 1919 World Series teams. Eddie hit a career best .369 for the White Sox in 1920, in the aftermath of the Black Sox Scandal. He led the league in stolen bases three times while with the Sox (33 in 1919, 47 in 1923, and 42 in 1924). Eddie was also a patient hitter, drawing a league-leading 119 walks in 1915. Collins was a part of Connie Mack's "$100,000 Infield" before he was sold to the Sox in 1915. He never led the league in hitting, mainly because he played at the same time as Ty Cobb. Collins was Columbia educated and one of the honest players on the 1919 White Sox team. Eddie Collins went on to manage the White Sox for the 1925 and '26 seasons. They finished over .500 each year, but only managed fifth place finishes both seasons. He was inducted to the Hall of Fame in 1939.

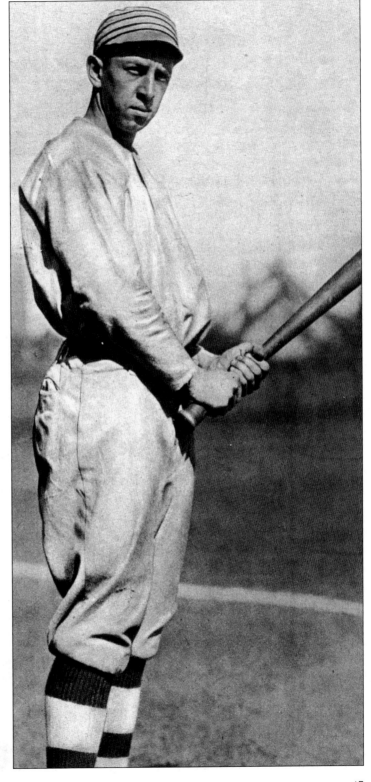

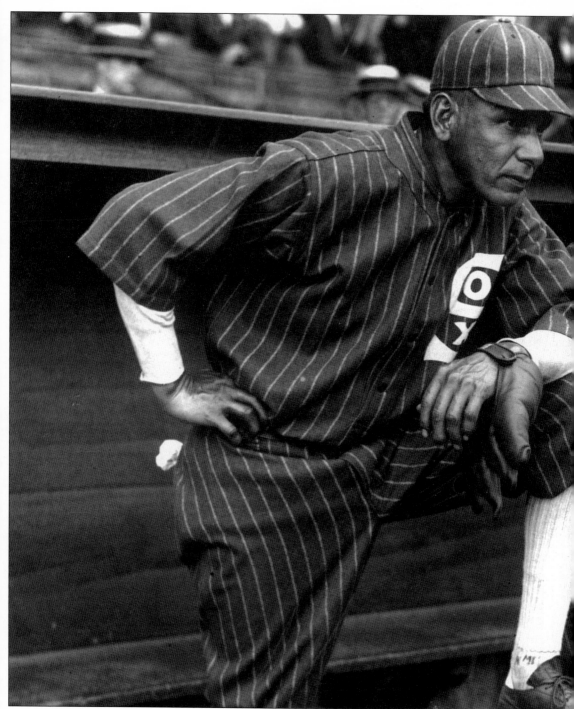

This is a rare photo of Chief Bender in a White Sox uniform, taken when he was a pitching coach in 1925 for his old A's teammate, Eddie Collins. Charles Albert "Chief" Bender was known for his prowess as a pitcher. Chief won 210 games and lost 127 in his storied career with the Philadelphia A's. He appeared in five World Series between 1905 and 1914 for Connie Mack, going 6-4 in the big games. Bender was a decent hitter for a pitcher, with a career .212

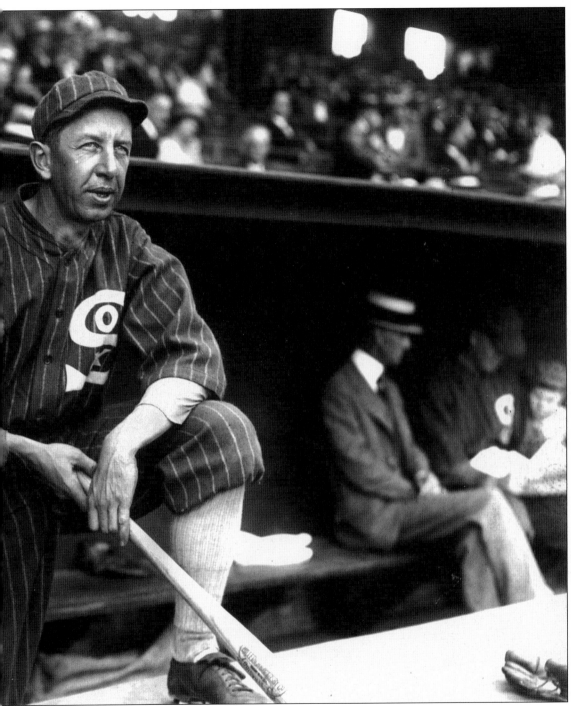

average and six home runs and 40 doubles. He appeared in one last game in 1925 for the White Sox. The Big Chief was inducted into the Hall of Fame in 1953. For many years, Bender, whose father was a German immigrant and his mother a Chippewa Indian, was the only Native American in the Hall of Fame.

Joseph Jefferson "Joe" Jackson
Career 1908–1920 Chicago 1915–1920

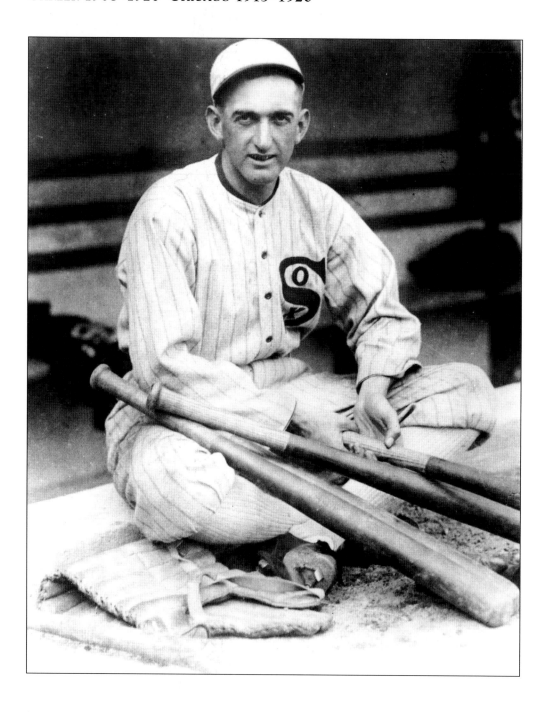

Joe was an uneducated cotton-mill Southerner who was never schooled in the ways of the book or the big city. The latter was his downfall. He was banned from baseball for accepting the promise of $5,000 for throwing the Series in 1919. Joe retired to South Carolina and opened a prosperous dry-cleaning business, which made him a lot of money. He eventually started a chain of dry cleaners. Shoeless Joe occasionally dug his bat, "Black Betsy," out of the moth balls for the outlaw leagues of the South, during the 1920s and '30s. It is said that he was always the best player on the field well into his forties.

"Shoeless Joe" was a career .356 hitter—third highest in major league history. What should have been a Hall of Fame career ended after the 1920 season, when he was declared ineligible for his role in the 1919 Black Stockings Scandal. Jackson played on both White Sox World Series teams of the late Teens (1917 and 1919). He had 202 hits, 40 doubles, and led the league in triples with 21, all while hitting .341 for the 1916 Sox. Sadly, his last season was his best (1920). Jackson hit .382 with 218 hits, 42 doubles, led the league with 20 triples, hit 12 home runs, and drove in 121 RBIs. His career average in the World Series is .345, including hitting

.375 in the Series he supposedly was involved in throwing. Jackson had what is considered the best rookie season ever with the 1911 Cleveland Indians. After playing parts of the previous three seasons with the Philadelphia A's, five games in 1908–09 and 20 games for the Indians in 1910, Jackson burst onto the scene in 1911 with a .408 average, which including 233 hits, 126 runs scored, and driving in 83 runs. He followed that up with almost identical numbers, with a .395 average, 226 hits, 26 doubles, 121 runs scored, and 90 runs batted in for the 1912 season. He was sold to the Sox when the Indians cleaned house in the middle of the 1915 season.

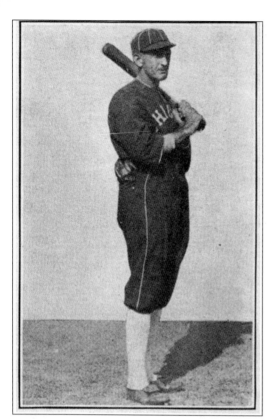

This 1920 Shoeless Joe Jackson baseball card would have been the prize possession of any young White Sox fan.

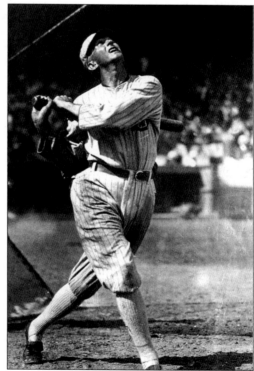

Jackson is seen here taking his rips with Black Betsy at the batting cage.

FREDERICK CHARLES "FRED" MERKLE
CAREER 1907–1926 CHICAGO 1917–1920

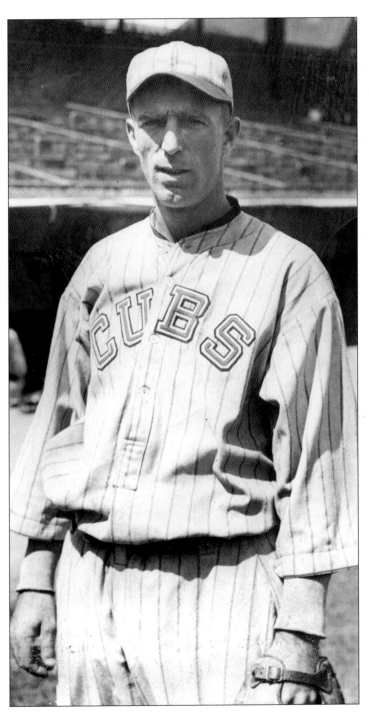

Merkle played first base for the 1918 pennant winning Cubs. Merkle was a career .273 hitter. He hit .297 for the 1918 Cubs. He had a nice career, but will always be infamously known as pulling off the famous "Merkle's Boner," as a Giant. Ironically, the "Boner" gave the Cubs the pennant in 1908. With a few weeks left in the season, the Cubs and Giants were in a tight pennant race. Merkle was on first when an apparent game-winning hit sailed into the outfield. Merkle, caught up in the excitement, never touched second base. Johnny Evers retrieved the ball and steps on the base for a force out. The Giant fans were already on the field and forced a replay of the game at the end of the season. The Cubs and Giants were tied for first when the make-up game was played, which the Giants lost. Merkle was haunted by the blunder for years, being 19 at the time of the incident.

John Francis "Shano" Collins
Career 1910–1925 Chicago 1910-1920

Shano was a career .262 hitter. Collins was a utility player for the 1917 and 1919 World Series teams, hitting .270 for both Series. Shano hit .303 in 1920, replacing the deposed Chick Gandil at first base. He had 17 triples in 1915. His best season was 1912, when he hit .294 with 34 doubles, and 10 triples. Collins was a versatile and cooperative player. After fizzling out at first base, he was shifted to right field, and was then moved back to first when the team needed. Shano, which is a Gaelic term for John (Sean-o), had the pennant clinching hit in 1917 and was instrumental in the series opening 2-1 victory, going three for four at the plate.

WILLIAM LAVIER "BILL" KILLEFER
CAREER 1909–1921 CHICAGO 1918–1921

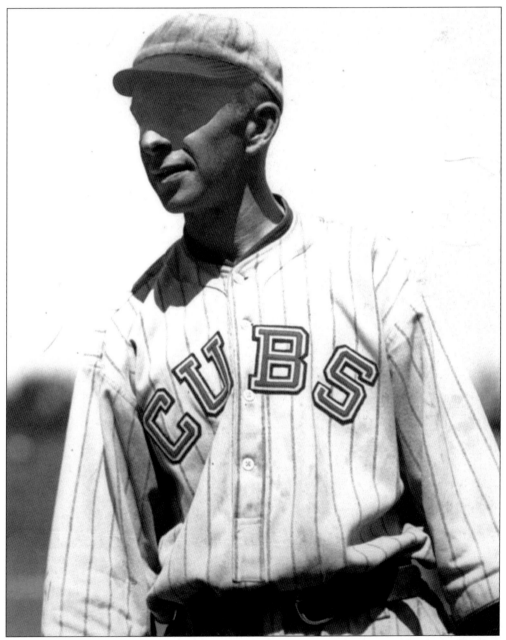

"Reindeer Bill" was a career .238 hitter. This tough catcher was the receiver for the Cubs' 1918 World Series team. Killefer hit .286 for the Cubs the following season. Bill was the preferred battery mate of Grover Cleveland Alexander and came to the Cubs when Alexander was traded before the 1918 season. When Killefer managed the Cubs from 1921 to 25, he was considered a developer of young catchers, including Gabby Hartnett as one of his students.

Charles Arnold "Chick" Gandil
Career 1910–1919 Chicago 1910, 1917–1919

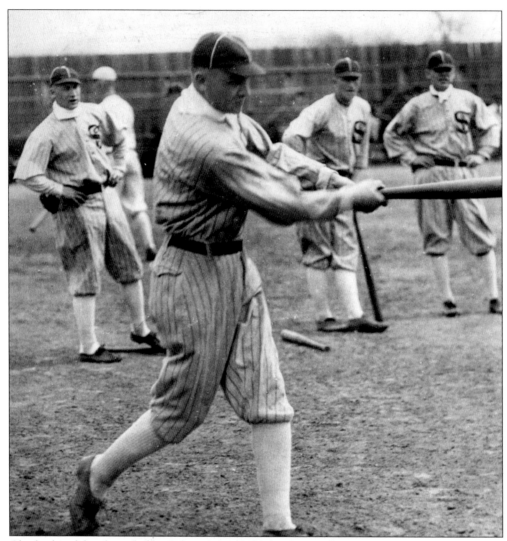

Chick played first base for the White Sox World Series teams of 1917 and 1919. A member of the infamous Black Stockings, Gandil was declared ineligible in 1920 due to his role in the scandal. A .277 lifetime hitter, Gandil hit .290 in his final season before his blackballing. He hit .233 in that infamous Series, ironically getting the game-winning hit in Game Six during the tenth inning. Gandil had a checkered past when he came back to White Sox in 1917, after a short stint with the team in 1910. He had made friends with a notorious gambler, Sport Sullivan, while playing in Washington. This relationship is believed to be Gandil's tie to the underworld that led to the thrown Series in 1919. Gandil was a 17-year-old runaway, who had fought for $150 in the rough towns of the Arizona-Mexico border, when the Sox signed him in 1910. In 1920, Gandil sat out the year in a salary dispute with Comiskey; fittingly, Gandil was declared ineligible the following season. Chick Gandil has been long regarded as the ring leader behind the Black Sox Scandal of 1919.

FRANK STEPHAN "PING" BODIE
CAREER 1911–1921 CHICAGO 1911–1914

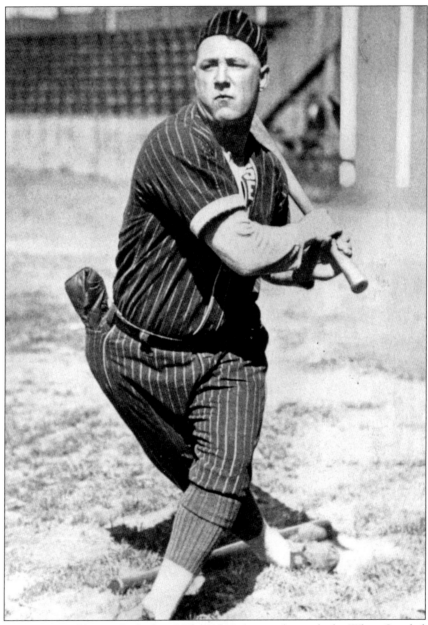

Ping was a career .295 hitter. Bodie hit .289 in 1911, as a rookie with the White Soc, belting 27 doubles, 13 triples, and 4 home runs. Ping followed it up with a strong sophomore season, hitting .294 with 24 doubles, 7 triples, and 5 home runs. He was a colorful but average ballplayer. Asked about rooming with gallivanting roommate, Babe Ruth, Ping dead-panned, "I don't room with Babe Ruth; I room with his suitcase." When the plodding Ping was thrown out by a mile, columnist Bugs Baer once quipped, "There was larceny in his heart, but his feet were honest."

OSCAR EMIL "HAPPY" FELSCH
CAREER 1915–1920 CHICAGO 1915–1920

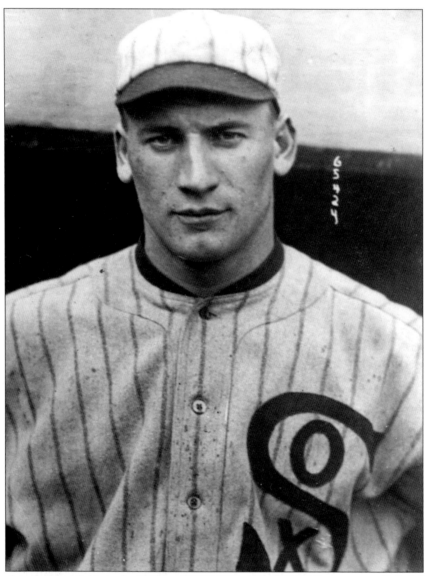

Happy played center field on the 1917 and 1919 White Sox World Series teams. Felsch hit .300 and .308 for 1916 and 1917 White Sox teams. He also had 102 RBIs in 1917 and 115 in 1920, his last season before being declared ineligible forever for his role in the 1919 Black Stocking Scandal. The rocket-armed Felsch still shares the records for double plays by an outfielder in a season (15) and assists in a game (4). Felsch once told author Eliot Asinof about the 1919 scandal, "There was so much crookedness around, you sort of fell into it. I was dumb, all right. We started out talking about all the big money we would take, like a bunch of kids pretending to be bigshots. I never really believed it would happen. And the next thing we knew, we were all tied up in it."

Fred "Cy" Williams
Career 1912–1930 Chicago 1912–1917

Cy was a career .292 hitter. Williams led the league in homers for the Cubs with 12 in 1916, when he hit .279. He went on to put up big numbers with the Phillies, once the dead ball period ended (1920), hitting over .300 six times and knocking out 41 homeruns in 1924. The Cubs brought Williams straight from Notre Dame where Williams played football with Knute Rockne and was a fine collegiate sprinter and hurdler. In one of the worst deals in Cubs' history, they traded the young Williams for a veteran outfielder, Dode Paskert. Williams' left-handed, dead-pull swing was perfect for Philadelphia's Baker Bowl. Williams went on to lead the league in homers in 1920 with 15, 1924 with 41, and 1927 with 30.

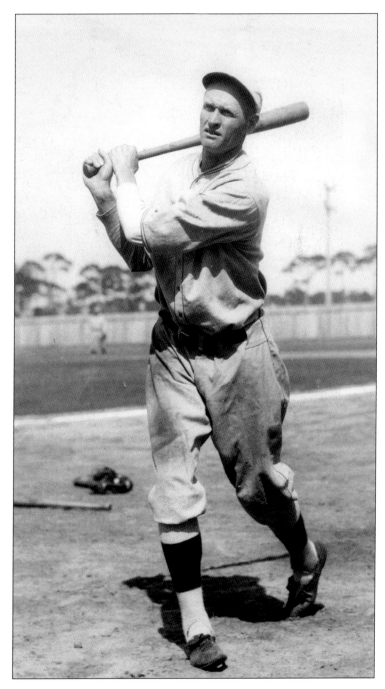

GEORGE DAVIS "BUCK" WEAVER
CAREER 1912–1920 CHICAGO 1912–1920

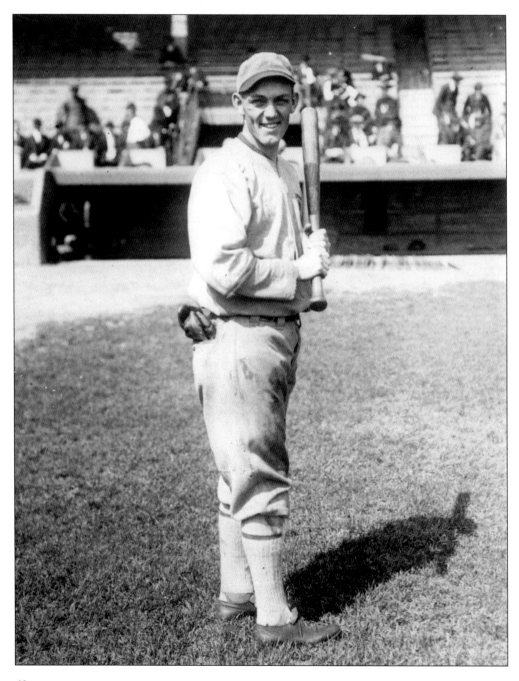

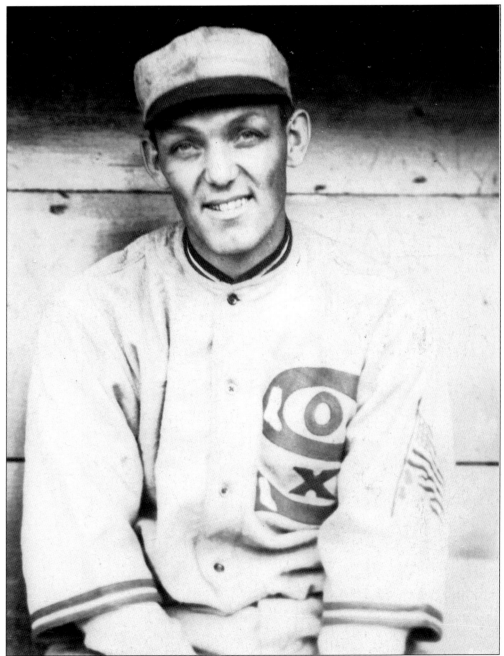

Buck was a career .272 hitter. Weaver was the backbone of the Sox infield of the Teens. He played third base on the World Series clubs of 1917 and 1919. Weaver had 75 RBIs in 1919 and again in 1920. Buck was declared ineligible in 1920 for his role in the 1919 Black Sox Scandal, though he hit .324 in the Series that he was supposedly throwing. Over his two World Series appearances, Buck hit a career .327 in 55 at-bats. Weaver never accepted a dime in the Black Sox Scandal, but he was dragged into it by Judge Landis, who banished him for not telling team officials of the fix. His anti-snitch constitution cost him his career. Chicago fans still petition for his pardon and reinstatement to this day.

Raymond William "Ray" Schalk
Career 1912–1929 Chicago 1912–1928

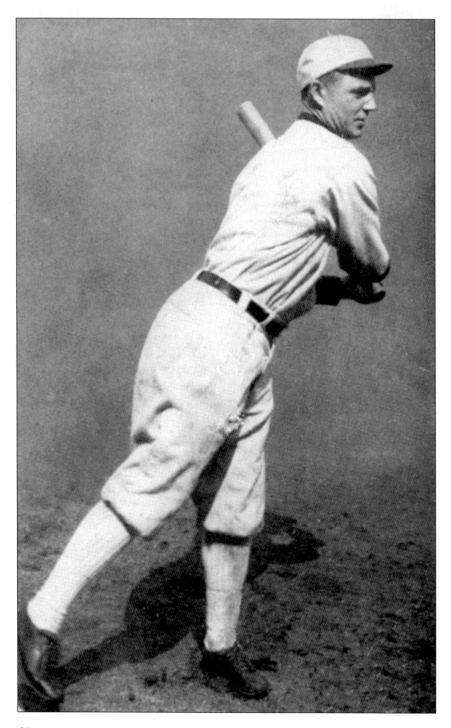

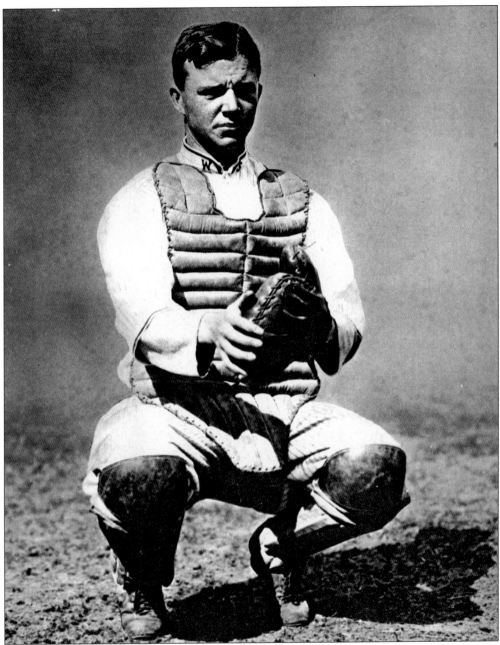

"Cracker" is the greatest catcher in the history of the White Sox. Schalk was a gritty catcher for the White Sox teams of the Teens and Twenties. He was a .253 career hitter. He hit a career best .282 for the 1919 White Sox. Ray also hit .286 in 42 World Series plate appearances between 1917 and 1919. Ray Schalk caught four no-hitters in his career, including Charlie Robertson's perfect game in 1922. At the time, he set career records for games played and putouts, and still holds the Major League record for double plays by a catcher. He also holds the American League record for assists by a catcher. As an innovator of the position, Schalk was the first catcher to run down the line to back up first base. Schalk was inducted to the Hall of Fame in 1955.

OSCAR CHARLESTON
CHICAGO 1918–19

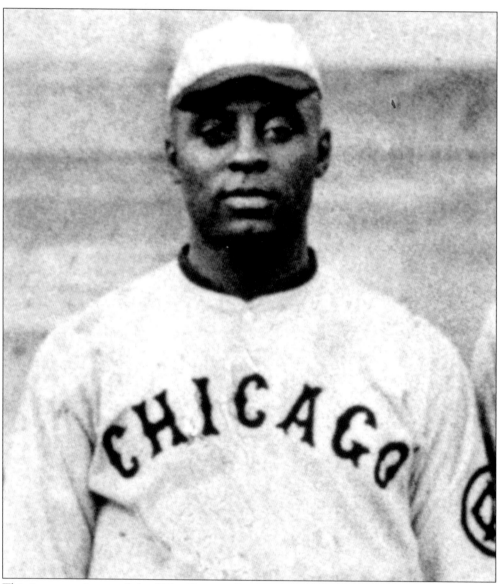

This is a rare picture of the "The Hoosier Comet" in a Chicago American Giants uniform. Charleston was a Negro League star who started his career in Chicago before heading to Indianapolis and then onto the Pittsburgh Crawfords, where he spent most of his career. Oscar was an All-star from 1933 to 1935 as a Pittsburgh Crawford. The Comet led the league in hitting (.446), home runs (14), and triples (10) in 1921, while with Indianapolis ABCs. Charleston was compared to many of his contemporaries. His aggressive base running style was compared to Ty Cobb. His top heavy structure and skinny legs were reminiscent of Babe Ruth. Charleston managed and played for the famed Pittsburgh Crawfords of the 1930s. He was inducted to the Hall of Fame in 1976.

1920–1950

The 20s were thin years for baseball in Chicago. The Sox were competitive in 1920, the year after the Black Stockings scandal, with the guilty players trying to prove they were on the up and up. That team finished second with a 96-58 record, two games behind the Cleveland Indians. After losing half their team to scandal, the 1921 White Sox finished 62-92 and took years to regain respectability. Not until 1936 did they finish in the top three in the American League.

On the Southside, there was at least some winning going on. The Chicago American Giants were owned and managed from 1911 to 1926 by the mastermind Andrew "Rube" Foster, the inventor of "tricky" baseball. He was inducted into the Baseball Hall of Fame in 1981. The American Giants were a fixture atop of the Negro National League throughout the 1920s, winning the Pennant in 1920, '21, '22, '26, and '27, dominating black baseball throughout the decade. Such stars as Bruce Petway, "Pop" Lloyd, and Cannonball Redding played on the early squads. Managed by "Gentlemen" Dave Malarcher, they beat the Bacharach Giants of Atlantic City in the Colored World Series in 1926 and 1927. On the roster in the '20s were Rube Foster's brother, Willie, "Colonel" Jimmie Crutchfield, and Ted "Double Duty" Radcliffe. The Giants under Foster played in the 5,000-seat stadium at 39th and Wentworth that White Sox owner Charles Comiskey gave up when he built the Baseball Palace of the World in 1910.

Rube Foster died in 1930, at a mental hospital, after years of trying to help Negro players be recognized as equals to the white major leaguers. His dream was realized in the next decade when the Kansas City Monarch's Jackie Robinson broke the color barrier.

The Cubs hovered around fourth and fifth place for much of the decade until finishing third in 1928 with a 91-63 record. The next year saw one of the greatest Cubs teams. They traded five players and $200,000 for Rogers Hornsby, and the pennant was theirs for the greater part of the next decade.

Manager Joe McCarthy's pennant-winning 1929 Cubs featured Hall of Famers Rogers Hornsby, Kiki Cuyler, and Hack Wilson. The team finished 98-54, nine and a half games ahead of the Pittsburgh Pirates. The outfield is still, to this day, the only starting outfield to have all three players drive in 100 RBIs in a season: left fielder Riggs Stephenson (110), center fielder Hack Wilson (159), and right fielder Kiki Cuyler (102). Rogers Hornsby hit .380 with 40 home runs and 149 RBI. Wilson, not to be outdone, hit .345 with 39 home runs and a National League leading 159 RBIs. Riggs Stephenson (.362) and Kiki Cuyler (.360) also pitched in to spark this potent line up. Pitchers Charlie Root (19-6) and Pat Malone (22-10) led a solid pitching staff.

The team lost a heart breaking World Series, four games to two, to the Connie Mack led Philadelphia A's. The A's were stocked with stars like Al Simmons, Mickey Cochrane, Jimmy Foxx, and Lefty Grove.

The Cubs trailed two games to one going into Game Four. They jumped out to a huge 8-0 lead and led by the same score going into the seventh inning. The A's woke up and pounded out a record 10 runs in the inning, aided by two fly balls that Hack Wilson lost in the sun. The A's won, 10-8, to take a 3-1 Series lead. In Game Five, the Cubs were ahead 2-0 in the bottom of the ninth, when the A's scored three runs to take the game, 3-2, and the Series four games

to one.

They finished in second place under Rogers Hornsby, who took over for Joe McCarthy with four games left, in the 1930 season. Chicago replaced Hornsby with Jolly Cholly Grimm with 57 games left in the 1932 season. The move worked and the Cubs won the National League by four games over the Pittsburgh Pirates. Riggs Stephenson (.324 BA) and Billy Herman (.314 BA) led the team in hitting. Pitcher Lon Warneke led the National League with 22 wins and a 2.37 ERA.

The Cubs ran into a buzz saw called the New York Yankees in the 1932 Series. The Yanks swept it in four games behind a combined seven home runs by Lou Gehrig (3), Babe Ruth (2) and Tony Lazzeri (2). The Cubs staff ERA was an astronomical 9.26 for the Series.

In the 1935 season, the Charlie Grimm led Cubs rallied at the end of the season by winning 21 games in a row, passing the St. Louis "Gashouse Gang" for the National League Pennant. The Cubs finished 100-54, four games ahead of the Cards. The Cubs had five .300 hitters on the team, led by catcher Gabby Hartnett (.344), second baseman Billy Herman (.341), center fielder Frank Demaree (.325), left fielder Augie Galan (.314), and third baseman Stan Hack (.311). Pitchers Lon Warneke (20-13) and Bill Lee (20-6) led the strong staff.

The big bats were stifled by the Detroit Tigers' Tommy Bridges and Schoolboy Rowe, beating the Cubs in the World Series, four games to two. Lon Warneke went 2-0 with a 0.54 ERA in that Series. Augie Galan and Chuck Klein both hit .333 in pacing the Cubs.

In 1938, Gabby Hartnett took over as player-manager for Charlie Grimm right after the All Star game, and the Cubs responded by catching and passing the Pittsburgh Pirates, beating them by two games. Hartnett's famous Homer in the Gloamin' was the highlight of the season and the highlight of Hartnett's career.

The reward was a rematch with the New York Yankees. Though Ruth-less, the Yankees had a different team including a young Joe DiMaggio, and the outcome was the same, with Yankee pitcher Red Ruffing baffling Cub hitters en route to a Series sweep for the Yanks. Ruffing (2-0, 1.50 ERA) and the .400 hitting of Bill Dickey and Joe Gordon was enough for the Yanks to dominate the Cubs again.

Both the Cubs and Sox finished in the second division until the Charlie Grimm led Cubs of 1945 beat the St. Louis Cardinals by three games to win the National League Pennant. Phil Cavarretta led the league in hitting with a .355 average and Andy Pafko led the Cubs with 110 RBIs. Pitcher Hank Wyse won 22 games and Hank Borowy led the league with a 2.13 ERA and an 11-2 record after coming over from the Yanks in mid-season. Borowy was 21-7 between the two teams that year. Third baseman Stan Hack hit .323. And the productive outfield of center fielder Pafko (.298, 12 HR, 110 RBIs), right fielder Swish Nicholson (.243, 13 HR, 88 RBIs), and left fielder Peanuts Lowrey (.283, 7 HR, 89 RBIs) was just enough to win 98 games that year.

In the Series of 1945, the Cubs won Game Six in the twelfth inning when Stan Hack doubled in the winning run. Hank Borowy, the losing starter in Game Five, pitched four hitless innings to pick up the win in Game Six. The Cubs gambled by sending Borowy back out for Game Seven, on one day's rest, hoping he'd regain some of the mustard he had in Game Six. The idea backfired. The Tiger's first three hitters single, knocking Borowy out of the game, en route to a five-run first inning. The Tigers go on to win the game, 9-3, and the Series four games to three. This marks the last time the Cubs made it to the World Series.

After a third-place finish in 1946, from 1947 to 1959 the Cubs finished in last place three times, and seventh place (out of eight teams) four times. They managed to scratch their way to a .500 finish in 1952 with a 77-77 mark.

The Jimmy Dykes managed White Sox teams of the 1930s and '40s were fairly competitive, usually hovering around third or fourth place pretty consistently, always close to the .500 mark, sometimes above, sometimes below. Not until Ted Lyons came along, after Dykes, did the Sox plummet to last place in 1948. Only when the Sox, in 1951, traded for Minnie Minoso did their luck seem to change . . . entering a new era.

68

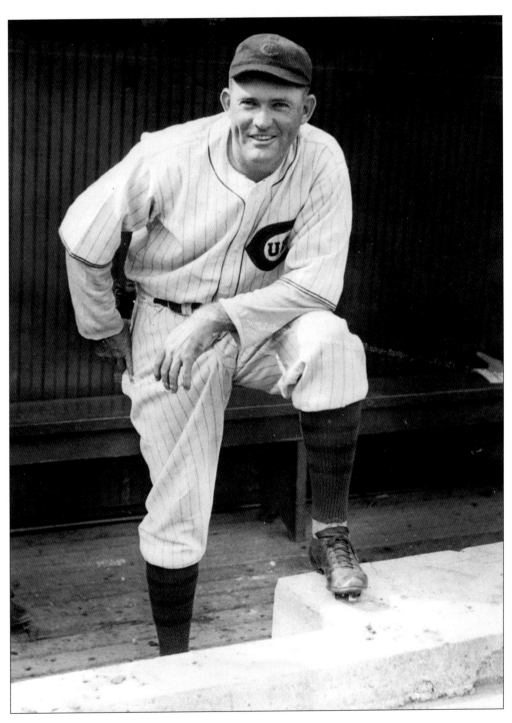

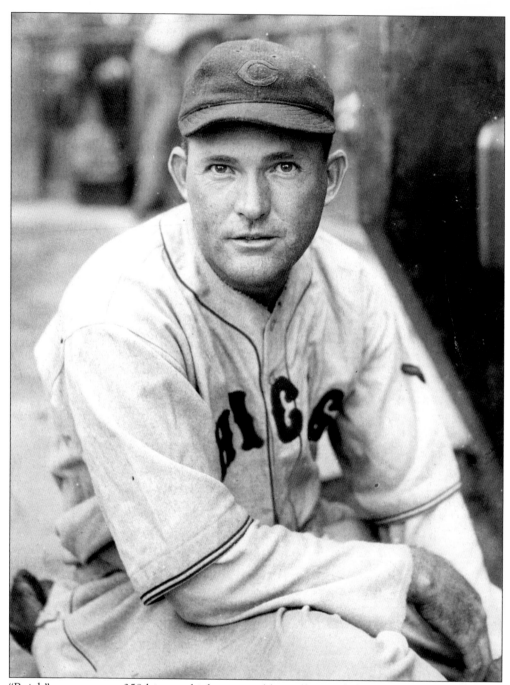

"Rajah" was a career .358 hitter, which is second best all-time, behind Ty Cobb. Hornsby led the league with a .424 batting average as a Cardinal in 1924, which is still a record in the modern era (post-1900). He led the league in 1929 with 156 runs scored as a Cub. Rajah also had 47 doubles, 40 home runs, and 149 RBIs in 1929, leading the Cubs to the pennant that year. He also won the National League MVP. Unfortunately, he only hit .238 in the Series that year. He was inducted to the Hall of Fame in 1942.

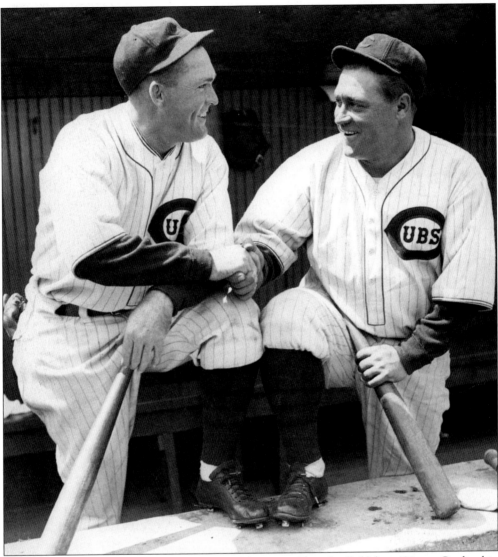

In one of the greatest seasons in the history of the game, Hornsby (left) hit .401 as a Cardinal in 1922, with 250 hits, 46 doubles, 42 home runs, and 141 RBIs. That made him a quintuple crown winner, leading the league in five offensive categories. Hornsby had a stance that took him to the back corner of the batter's box, and he approached the plate with an even swing, providing power to all fields. (It was similar to today's softball swing, where you "take a run at a pitch.") Rajah had a tumultuous relationship with Cardinals owners and soon after, the Cubs traded five players and $200,000 for him. Hornsby was cool and distant with teammates. His horse betting cost him his managing job with the Cubs in 1932. In 1932, under Charlie Grimm, the players showed their disdain by not voting him a World Series share. Hornsby was also the main reason why Hack Wilson (right) was allowed to leave Chicago. Hornsby was a teetotaler and felt that everyone should lead the same life that he did. Hack Wilson, on the other hand, was the complete opposite of a teetotaler. Wilson was a beer guzzler. After Wilson had a weak season in 1931, Hornsby felt that the evil spirits of alcohol had affected Hack's game, which it probably had, but that year the Major Leagues had gone back to a dead ball, so power numbers took a sharp decrease. Hornsby didn't care and wanted Wilson gone. Hack was in Brooklyn for the 1932 season.

CHARLES JOHN "CHARLIE" GRIMM
CAREER 1916–1936 CHICAGO 1925–1936

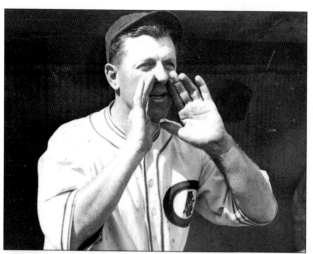

Cholly was a first baseman by trade, but one of the most successful managers in the history of the game, winning 2,370 games in his long managing career. Charlie Grimm had three stints as a Cub manager. From 1932 to 1938, replacing Rogers Hornsby in mid-season 1932 and taking the team to the pennant. In 1938, he was replaced by Gabby Hartnett, who went on to win the pennant. He took the team over again in 1944 and led the Cubs to the World Series in 1945. Cholly had one last stint with the Cubs late in his career, in 1960, when he coached 17 games for the last-place Cubs.

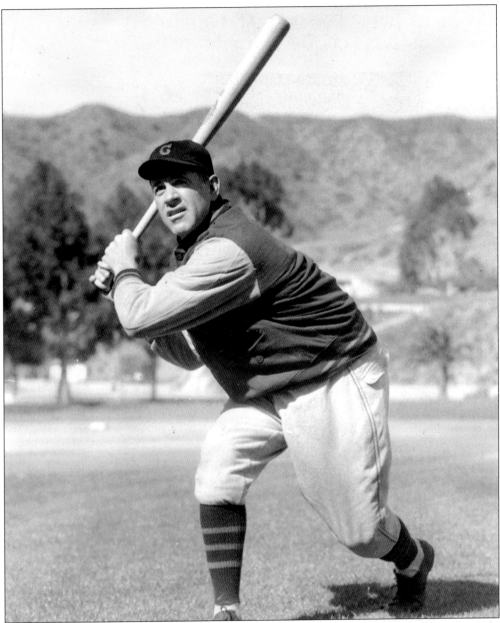

Here's Charlie during spring training on Catalina Island, California. Grimm played on the Cubs World Series teams of 1929, 1932, and 1935. Cholly was the manager of the 1932 and '35 Series teams. "Jolly Cholly" was a career .290 hitter. Grimm hit .331 in 1931. He also had 10 homers and 91 RBIs in 1929. Grimm's best offensive season was 1932, when he had 42 doubles and hit .307. Grimm won nine fielding titles and was considered the best defensive first baseman of his era.

James Joseph "Jimmy" Dykes
Career 1918–1939 Chicago 1933–1939

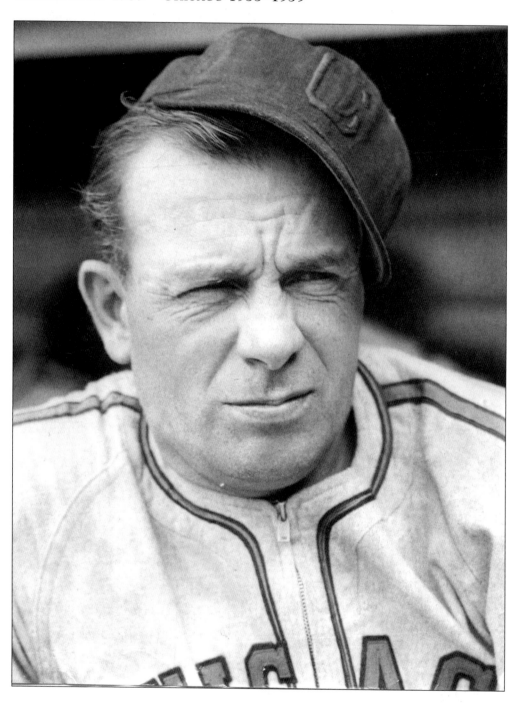

Jimmy Dykes played 15 years for Connie Mack before joining the Sox in 1933. Dykes became the Sox manager for the next 12 seasons. He was a career .280 hitter. Dykes was an average manager with the White Sox, never finishing higher than third place during his tenure. Under his guidance, the Sox always stayed dangerously close to .500, but never really seemed to turn the corner, an affliction that has followed the White Sox well into this century. A's coach Connie Mack once said of Dykes, "Having one Dykes is like having five or six players and only one to feed, clothe, and pay." Dykes played every position for Mack except pitcher and catcher. He was sold to Sox along with Bucketfoot Al Simmons and Mule Haas for $100,000. Dykes once declined to make an offer to Jackie Robinson after Robinson tried out in 1942.

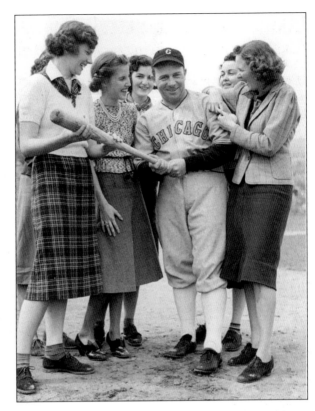

FRED "DIXIE" WALKER
CAREER 1931–1949 CHICAGO 1937

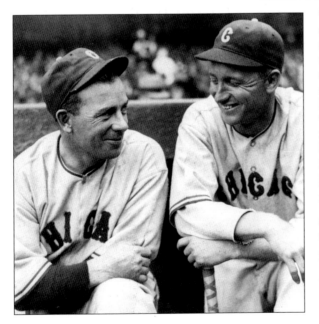

"The People's Cherce" (left) was a career .306 hitter. Dixie was an All-star in 1943, '44, '46, and '47 with the Brooklyn Dodgers. He had a sweet season with the Sox in his only year, 1937. Walker led the league in triples with 16, while whopping 28 doubles and driving in 95 runs, hitting .302. This was his first good season as a professional. He became a solid player later in his career as The People's Cherce in his years at Brooklyn. Early in his career, shoulder injuries kept him from staying in one place for too long. After hurting his knee in 1939 with Tigers, Walker spent the rest of his career as the People's Cherce, where he was beloved by the Brooklyn Bums.

Charles Jacob "Charlie" Hollocher
Career 1918–19 24 Chicago 1918–1924

Hollocher's successful career was cut short due to illness in 1924. He was a career .304 hitter for the Cubs, the only team he ever played for. He hit .340 with 201 hits in 1922, his last full season. Charlie sat more than he played, due to psychosomatic illnesses. There was more in his head going on, than in his body. Eventually, Hollocher committed suicide in 1944, supposedly pining for the career he threw away.

JOHN ANTHONY "JOHNNY" MOSTIL
CAREER 1918–1929 CHICAGO 1918, 1921-1929

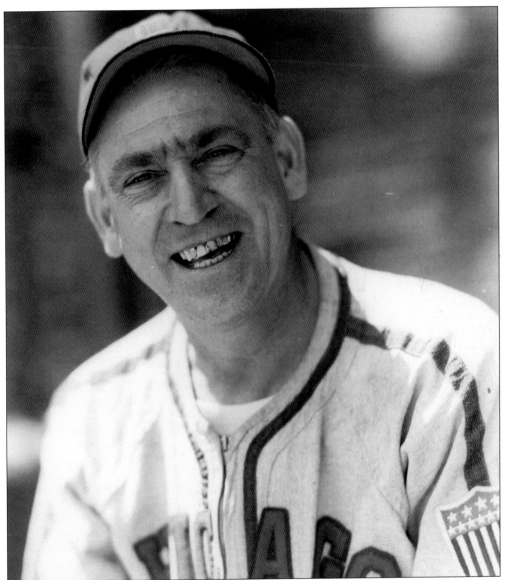

"Bananas" was a career .301 hitter. Mostil led the league in 1925 with 90 walks, 135 runs scored, and 43 stolen bases. He again led the league in 1926 with 35 stolen bases. Mostil hit over .300 four times in his career. He was so fast, Mostil once caught a foul ball during spring training down the left field line—while playing center field. Mostil was rumored to be having an affair with Red Faber's wife when he tried to kill himself in 1927. Mostil's doctors claimed that he suffered from neuritis. The media played on the fact that Faber threatened to kill Mostil. Some people actually believe it was Faber himself who tried to get rid of Mostil, and the cuts on his wrists came in defense of an outraged Faber. The world will never know, but it's an intriguing story.

Jackson Riggs "Riggs" Stephenson

Career 1921–1934 Chicago 1926–1934

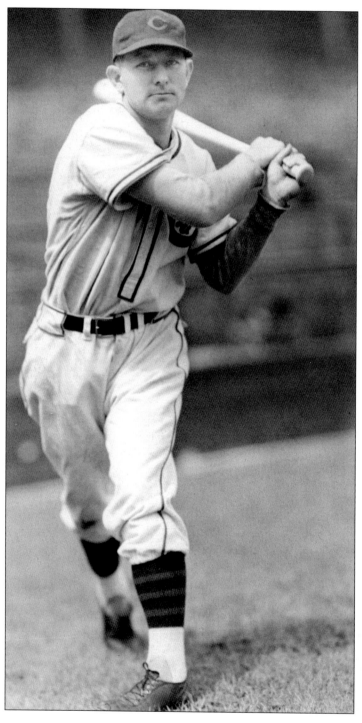

"Old Hoss" was a career .336 hitter for the Cleveland Indians and Chicago Cubs. Stephenson found himself in the outfield with Hall of Famers Hack Wilson and Kiki Cuyler for the Pennant winning Cubs of 1929 and 1932. It is still the only outfield to have driven in 100 RBIs or more at each position— Stephenson (110), Wilson (159), and Cuyler (102). Riggs hit .363 for the 1929 team, knocking in 110 runs. He hit .314 for the 1932 Cubs and ripped 49 doubles that year to lead the league, which matched his career high of 49 hit in 1927 for the Cubs. Stephenson was a monster in the World Series, hitting a healthy .378 in 37 Series at-bats. He had a career-long problem with his throwing arm, being released by the Indians because of it. The Cubs needed his offense and tried to hide his arm between two strong outfielders.

BIBB AUGUST FALK
CAREER 1920–1931 CHICAGO 1920–1928

EARL HOMER SHEELY
CAREER 1921–1931 CHICAGO 1921–1927

"Jockey" was a career .314 hitter. Falk hit a whopping .352 for the 1924 White Sox. Bibb had 99 RBIs in 1924, 99 in 1925, and 108 in 1926. He also hit .345 in 1926. Falk, after leaving college, succeeded the banished Joe Jackson in left field. Falk was also an All-conference football player at the University of Texas.

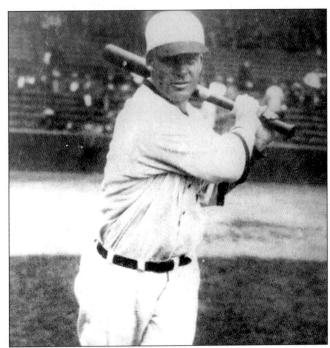

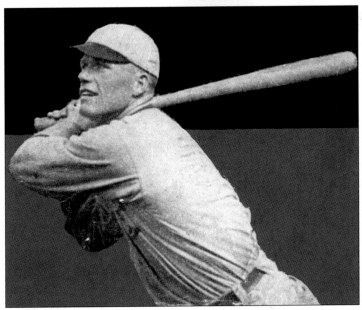

"Whitey" was a career .300 hitter. Sheely had a great rookie season in 1921, hitting .304 with 11 home runs and 95 RBIs. In 1924 and '25, he put together back-to-back stellar seasons. He hit .320 in 1924 with 103 RBIs, and .315 in 1925 with 43 doubles and 111 RBIs. Sheely also led first basemen in fielding in 1926. Sheely has been described as slow of foot with a knack for driving in runs.

HAZEN SHIRLEY "KIKI" CUYLER
CAREER 1921–1938 CHICAGO 1928–1935

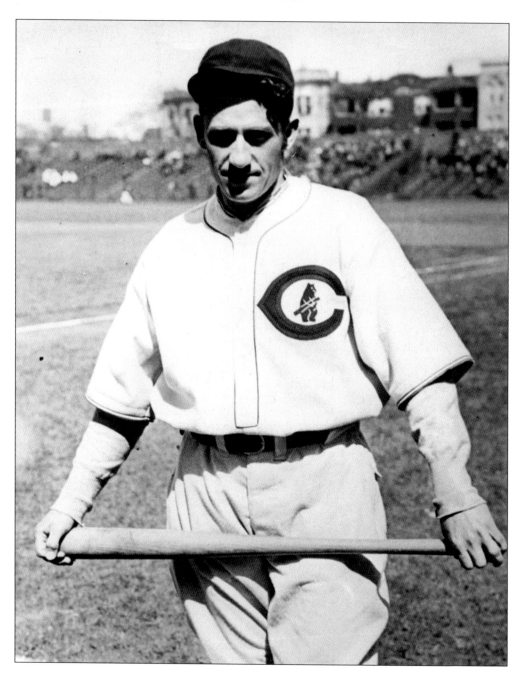

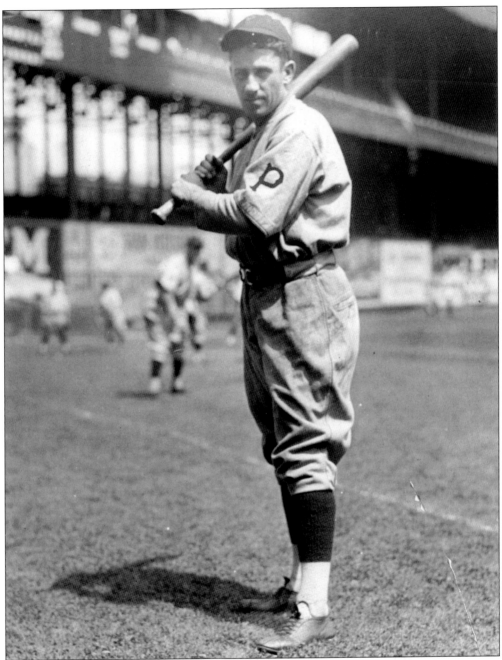

Kiki was a career .321 hitter. Cuyler led the National League in stolen bases in 1928 with 37, 1929 with 43, and 1930 with 37. Hazen hit .360 in 1929 and .355 in 1930 with 228 hits. Cuyler played on the 1929 and 1932 Cubs World Series teams. Kiki was traded right before Cubs made their run at the pennant in 1935. Cuyler finished second to Rogers Hornsby in 1925 for the MVP while at Pittsburgh (pictured above). He was traded to the Cubs when Lloyd Waner's production in Pittsburgh made Cuyler expendable. He enjoyed several good seasons with the Cubs, but a broken foot in 1932 slowed him down on the base paths and he was out of ball a few years later. He was inducted to the Hall of Fame in 1968.

CHARLES LEO "GABBY" HARTNETT
CAREER 1922–1941 CHICAGO 1922–1940

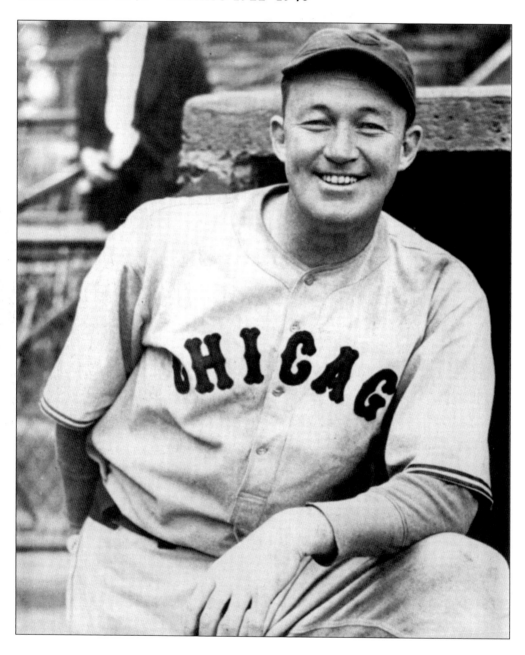

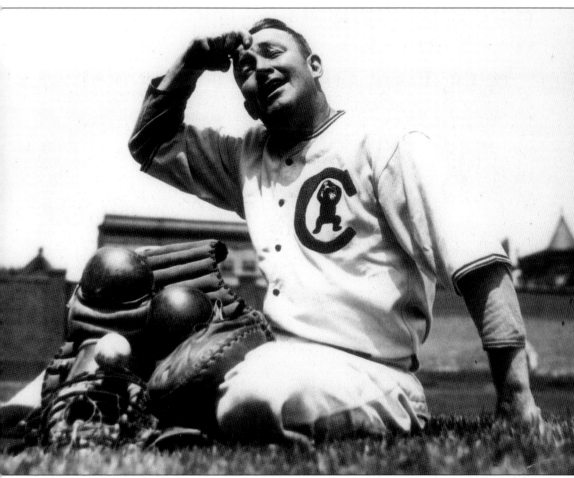

Gabby was a career .297 hitter. Hartnett played 19 seasons out of his 20-year career as a Cub. Gabby managed the Cubs to a pennant in 1938, after replacing Cholly Grimm in mid-season. Hartnett played on a total of four Cubs World Series teams (1929, '32, '35, and '38). Gabby hit 37 home runs and 122 RBIs in 1930, and batted .354 in 1937. Hartnett was the oldest son of a semi-pro catcher and coach, Fred Hartnett. Gabby had the "Hartnett arm." He got the ironic nickname "Gabby" because of his shy nature. Hartnett was the catcher when Carl Hubbell fanned Ruth, Gehrig, Foxx, Simmons, and Cronin in the 1934 All Star game. League MVP in 1935, Gabby's crowning moment was in 1938. He is best known for that year's "Homer in the Gloamin'." With the score tied 5-5 in the ninth and darkness and fog looming at Wrigley, Hartnett hit an 0-2 pitch with two out for a walk-off home run. Three days later, the Cubs clinched the Pennant. Hartnett had also been made manager at mid-season of that year. He was inducted to the Hall of Fame in 1955.

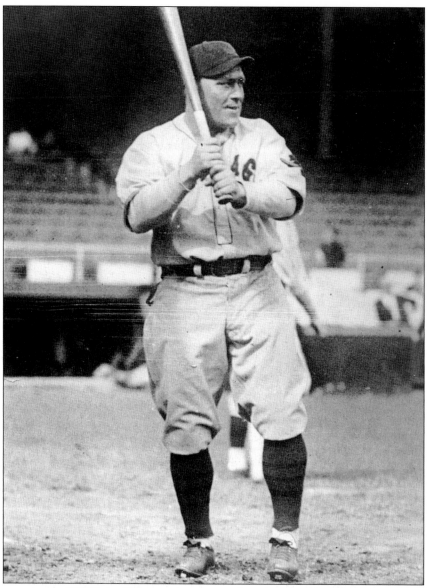

Hack was a career .307 hitter. Wilson, a hammering hitter and a slow-footed center fielder, was 5-foot-6 and 195 pounds with a barrel chest and hands like a bricklayer. Wilson led the league in home runs in 1926 (21), 1927 (30), 1928 (31), and 1930 (56). He had 39 home runs in 1929 and a league-leading 159 RBIs. In Wilson's best season (1930) he batted .356 with 56 home runs and 190 RBIs, a record that still stands today. His average dropped 100 points in 1931, and his power numbers also dropped, in part because baseball went back to a "dead" ball. He was gone from the Cubs by 1932. They say that alcohol ended Hack Wilson's career. Some have said that McCarthy could handle him in New York, but Hornsby couldn't in Chicago. Hornsby and Wilson were like oil and water. Historians say Hornsby was jealous of Wilson's power and his notoriety as a home-run hitter. Hornsby felt he was better. Regardless, Hornsby had enough influence to get Wilson chased out of town after a mediocre 1931 season for Wilson (.261, 13 home runs, 66 RBIs). Wilson was out of baseball after the 1934 season. He hit .471 in his only World Series appearance with the Cubs (1929). He was inducted to the Hall of Fame in 1979.

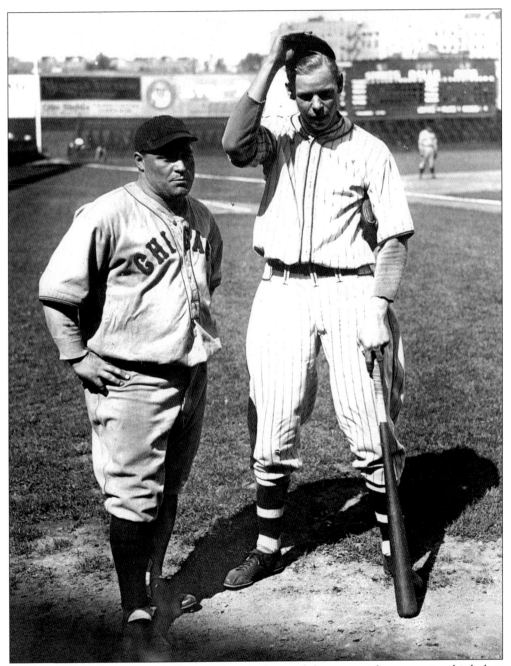

Herman (right), seen here with Hack Wilson, had two solid seasons with consecutive third-place Cubs teams. In 1933, he hit .289 with 16 home runs and 93 RBIs. He followed that up with a .304/14/84 performance in 1934. Herman was a career .324 hitter and one of only two major leaguers to hit for the cycle three times (Bob Meusel was the other).

George William "Mule" Haas

Career 1925–1938 Chicago 1933–1937.

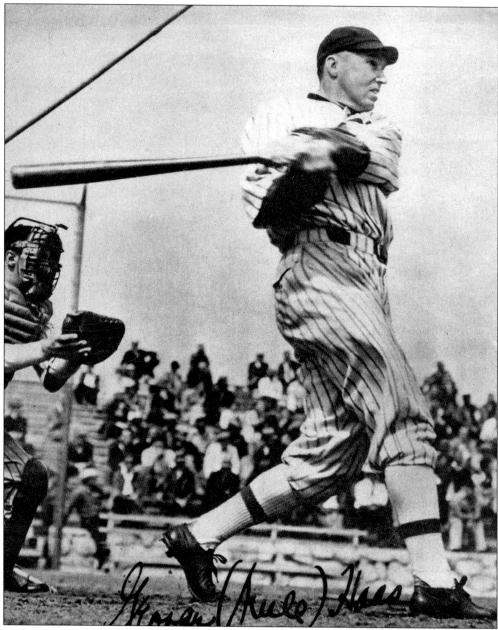

Mule was a career .292 hitter. Haas hit a solid .287 in 1933, his first with the Sox. The Mule appeared in three World Series with Connie Mack's teams on the early 30s. Haas learned to play center from Tris Speaker, cheating in and making looping catches over his head. Haas was one of three players sold to the Sox in 1933 by Connie Mack of the A's for $100,000. Al Simmons and Jimmy Dykes were the others. Haas was a solid, unassuming ballplayer with average numbers in hitting and fielding, but he had a long and productive career.

William Edward "Willie" Kamm
Career 1923–1935 Chicago 1923–1931

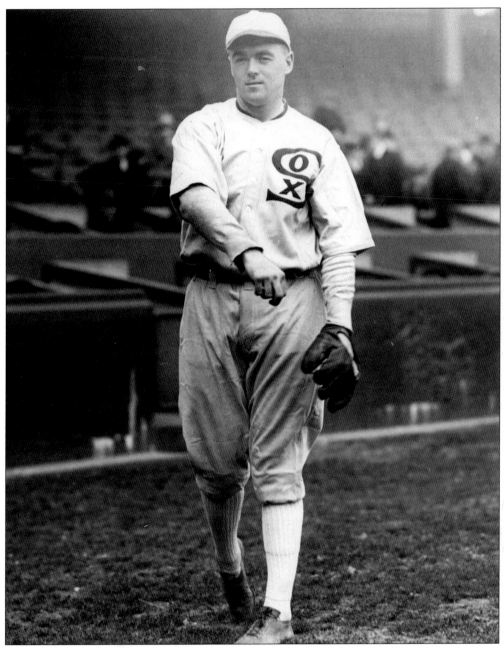

Willie was a career .281 hitter. Kamm drove in 80 runs or more four times for the Sox between 1923 and 1928. Willie hit. 292 his rookie year with 39 doubles and 87 RBIs. He also hit .308 for the 1928 Sox with 84 RBIs. The Sox bought Kamm for $100,000 in 1923 from the San Francisco Seals. Kamm was to fill the gap Buck Weaver left when banished from the league. Kamm was a solid third baseman and considered a clutch hitter during his time with the Sox.

Aloysius Harry "Al" Simmons (Aloysius Szymanski)
Career 1924–1944 Chicago 1933–35

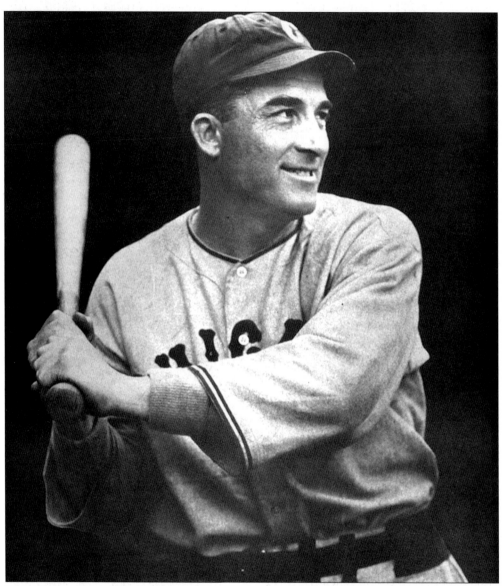

"The Duke of Milwaukee" was a career .334 hitter. "Bucketfoot Al" was the star of Connie Mack's powerhouse teams of the late 1920s and early '30s. Simmons hit .381 in 1930 and .390 in 1931 for the A's to lead the league. In his brief stint with the Sox, he hit .331, in 1933, with 200 hits and 119 RBIs. He hit .344 in 1934 with 104 RBIs. His production dropped off in 1935 (.267, 16 HR, 68 RBIs) and he was out the door in 1936. Simmons was called Bucketfoot because of his peculiar stance for a right-handed hitter. Bucketfoot Al stepped "in the bucket" by bailing out on pitches as he swung. He was strong and used a long bat, giving him the ability to use the whole field. He was inducted to the Hall of Fame in 1953.

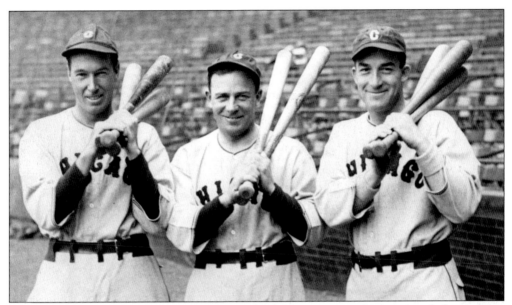

The sluggers—Mule Haas, Jimmy Dykes, and Al Simmons—as they appeared shortly after being acquired by the White Sox.

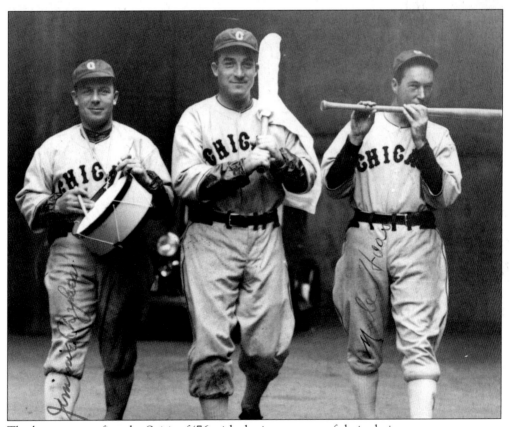

The boys are spoofing the Spirit of '76 with the instruments of their choice.

ANTHONY MICHAEL "TONY" LAZZERI

CAREER 1926–1939 CHICAGO 1938

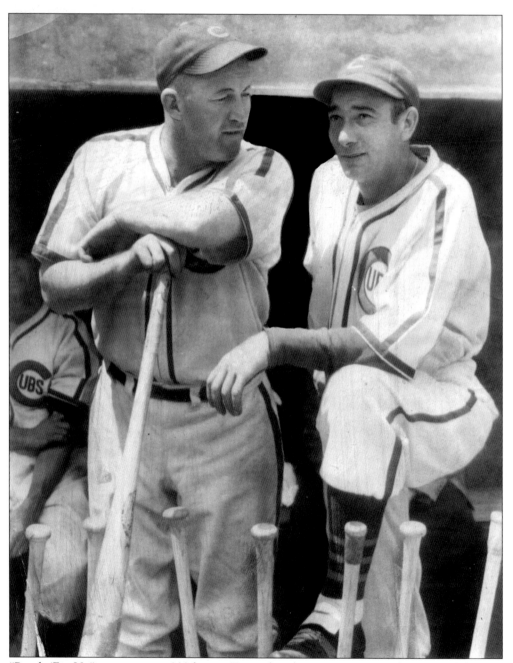

"Poosh 'Em Up" was a career .292 hitter. Tony played one season as a substitute infielder on the pennant winning 1938 Cubs. Lazzeri was better known for his years on the "Murder's Row" Yankee teams of the 1920s and '30s. Lazzeri drove in more than 100 runs seven times in his career. Poosh was at the end of his career when he played with the Cubs.

ELWOOD GEORGE "WOODY" ENGLISH
CAREER 1927–1938 CHICAGO 1927–1936.

Woody was a career .286 hitter. English played on the Cubs 1929 and 1932 World Series teams. Woody hit .335 in 1930 with 17 triples, 14 home runs, and 100 walks. He also had 214 and 202 hits in 1930 and '31, respectively. English once won a suit as a Dodger late in his career by hitting a clothier sign in old Ebbets Field.

Charles Herbert "Chuck" Klein
Career 1928–1944 Chicago 1934–1936

Chuck Klein came to Chicago after winning the Triple Crown in 1933. Though his years in Chicago were reasonably productive, they didn't match the monster years he had in Philly. Klein was a career .320 hitter. He hit .310, with 20 homers and 80 RBIs, in 1934 and .293, with 21 homers and 73 RBIs, in 1935 for the Cubs, before being traded back to Philly during the 1936 season. He hit a combined .306, 25 home runs, and 102 RBIs for those two teams in 1936. Klein's numbers never came close to that after the 1936 season. The average was always good, but his power numbers disappeared. Klein hit .333 in the 1935 Series for the Cubs. Many blame Klein's lofty numbers before he was a Cub on the cozy Baker Bowl in Philly. His home runs there became long outs in Wrigley Field.

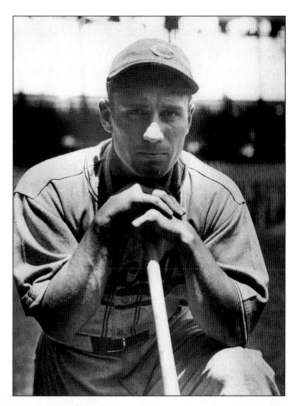

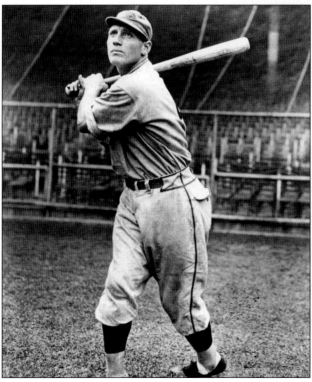

Klein hurt his leg during the 1934 season and many think this was the beginning of the end for him. He was never able to generate the power he once did in Philadelphia. Klein never hit more than 20 home runs after leaving the Cubs and was a role player by 1940 with only token appearances and pinch-hitting assignments. He was inducted to the Hall of Fame in 1980.

Joseph Anthony "Joe" Kuhel
Career 1930–1947 Chicago 1938–1943, 1946–47

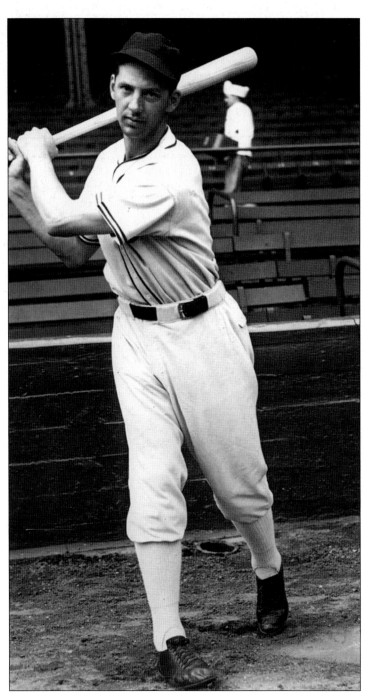

Joe was a steady .277 hitter for the White Sox. Kuhel came in on a trade from the Washington Senators for popular first baseman Zeke Bonura. The Comiskeys took a lot of heat from the fans for trading the flamboyant Bonura. Kuhel had led the league in fielding and continued his slick glove work for the White Sox. Joe's best season for the Sox was 1940, when he hit .280, popped 27 home runs, drove in 94, and scored 111 runs. Joe had hit .321 for the 1936 Senators, while driving in 118 runs. Kuhel was a fearless player, taking on pitcher Eldon Auker and the entire St. Louis Browns bench after getting beaned in the head.

CHALMER WILLIAM "BILL" CISSELL
CAREER 1928–1938 CHICAGO 1928–1932

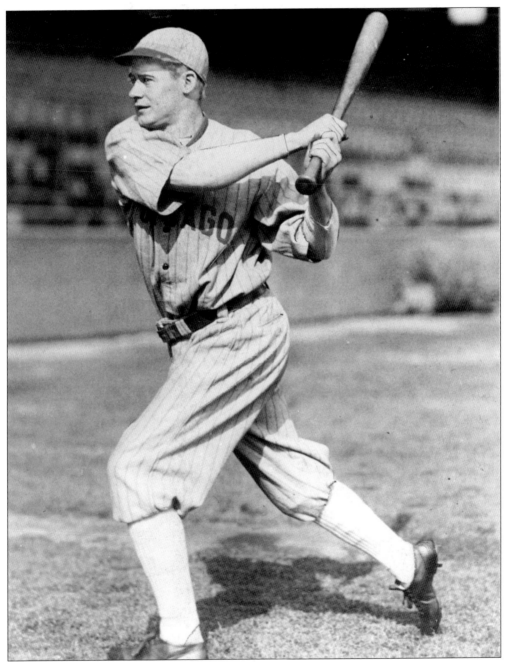

Bill was a career .267 hitter. Cissell was the everyday shortstop and switched to second base when Luke Appling came to town. The best season Cissell had for the Sox was in 1929 when he hit .280 with 27 doubles, 12 triples, and 5 home runs.

LUCIUS BENJAMIN "LUKE" APPLING
CAREER 1930–1950 CHICAGO 1930–1950

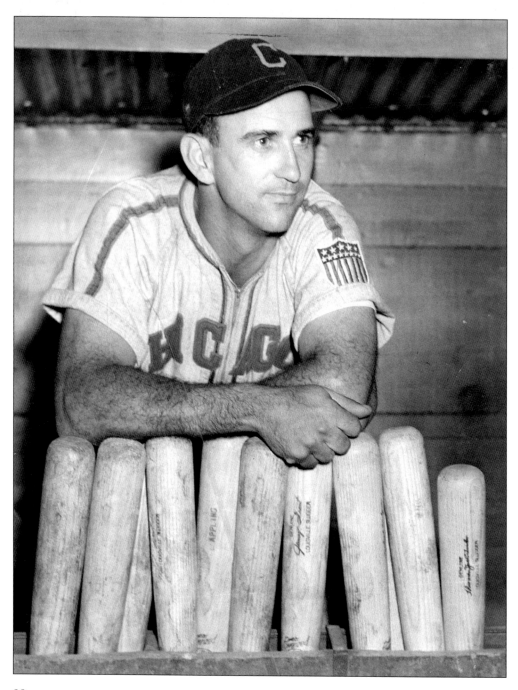

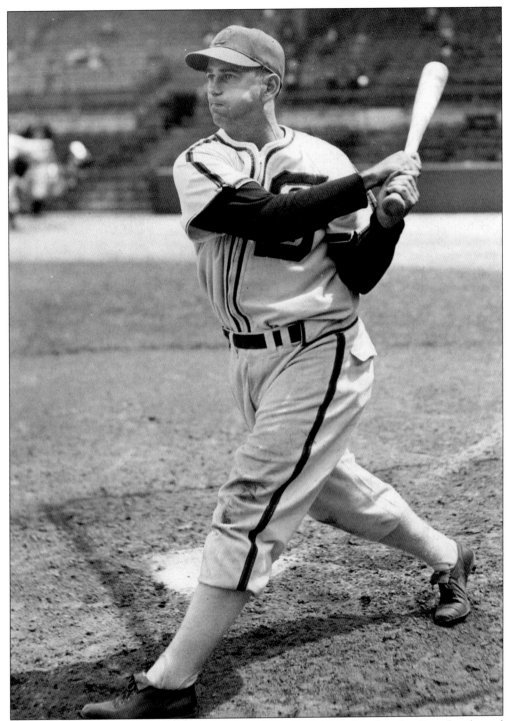

"Old Aches and Pains" played 2,422 games for the Sox over two decades. Appling also slapped around the ball for 2,749 hits. Luke had a .310 lifetime batting average. Appling led the league with a .388 average in 1936, and .328 in 1943. He missed two seasons because of World War II. He was inducted to the Hall of Fame in 1964.

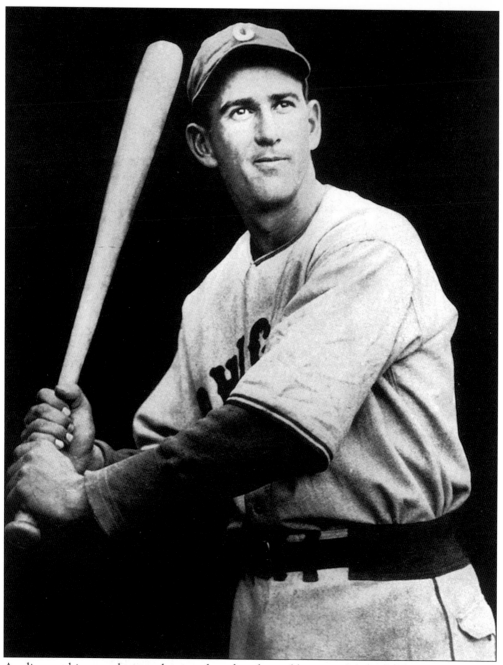

Appling got his name by complaining about his physical being and the infield of Old Comiskey Park. He stated, "It must have been built on a junkyard," which it was. Appling adjusted his hitting stance to use the cavernous Comiskey to his advantage. He hit .300 or better 15 times in his career. Legend has it that Appling once fouled off 17 pitches before hitting a triple.

William Jennings Bryan "Billy" Herman
Career 1931–1947 Chicago 1931–1941

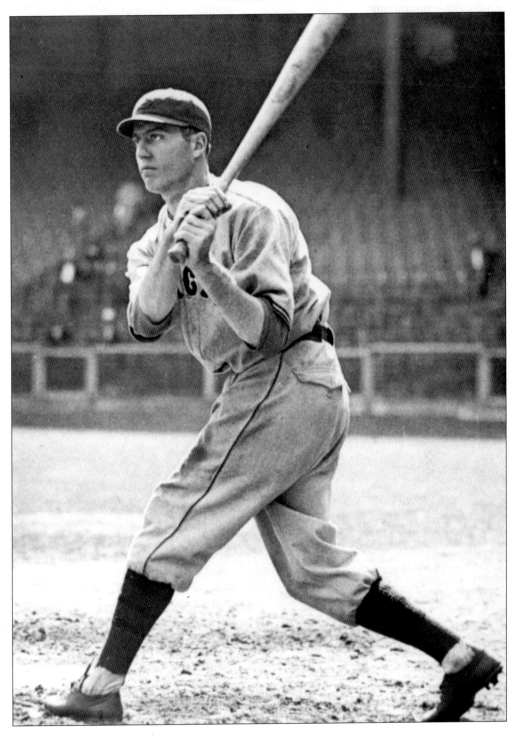

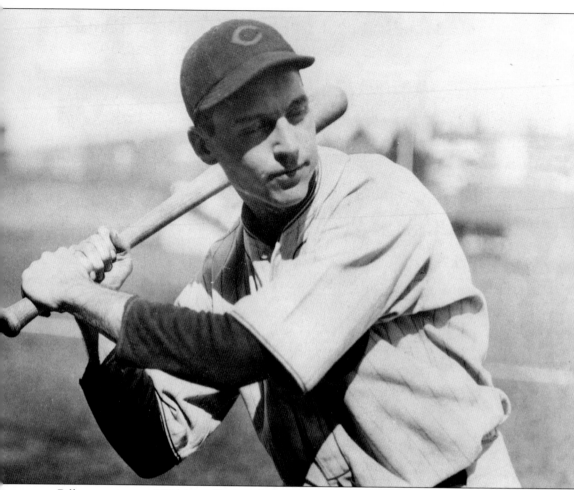

Billy was a career .304 hitter. Herman hit a league-high 57 doubles in 1935, along with a .341 average. He also led the league in triples in 1939 with 18. Herman played on three Cubs pennant winners (1932, '35, and '38). Herman teamed with Billy Jurges to be the top double play combination in the 1930s. He was the top fielding second baseman for a decade. He led the league in assists and putouts for second basemen seven times. Jimmy Wilson traded Herman in 1941 because he thought he was a threat to his job. Lucky for Herman, he went to Brooklyn and got to play in the World Series. The much hated and paranoid Jimmy Wilson was fired in 1944 after a 1-9 start, and replaced by Charlie Grimm. Herman was inducted to the Hall of Fame in 1975.

WILLIAM FREDERICK "BILL" JURGES
CAREER 1931–1947 CHICAGO 1931–1938, 1946–47

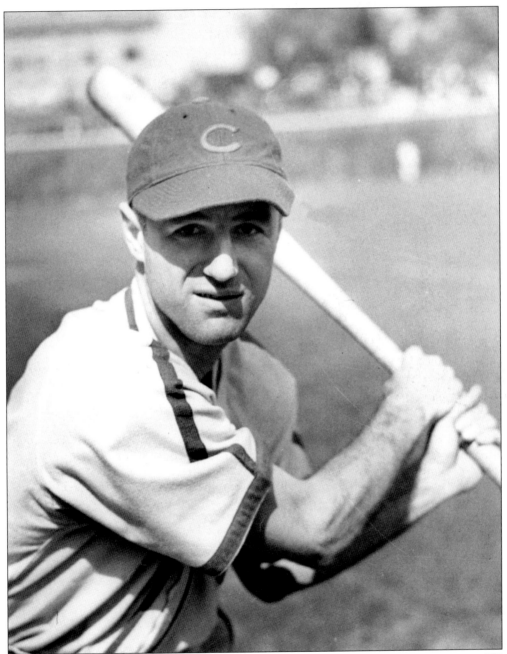

Bill played on three Cubs World Series teams (1932, '35, and '38). Jurges was a career .258 hitter. His best season was 1937, when he hit .298 for Cubs. Jurges also posted a career .275 World Series average in 40 at-bats. Jurges was better known as a slick fielding shortstop, being teamed with Billy Herman to have the top double play combination of the 1930s.

STANLEY CAMFIELD (STAN) HACK
CAREER 1932–1947 CHICAGO 1932–1947

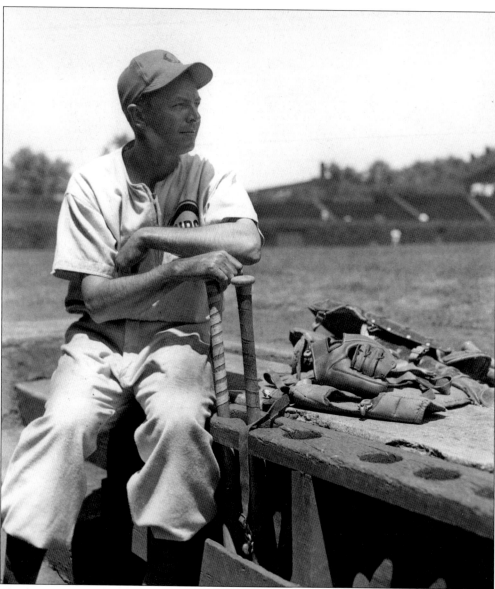

"Smiling Stan" spent his playing days as a cornerstone at the hot corner at Wrigley Field for 16 years. Hack played on four Cubs World Series teams (1932, '35, '38, and '45). He was a .301 career hitter. Hack led the league in hits in 1940 with 191, and again in 1941 with 186. The speedy Hack led the league in stolen bases in 1938 (16) and 1939 (17). Hack also hit .323 in 1945 for the pennant winners. He tore it up in the big games, hitting .348 in 64 career World Series plate appearances. Hack was a fan favorite. After Jimmy Wilson took over as coach, Hack "retired" in 1943, only to come back in 1945 for another pennant run with Charlie Grimm as manager, after Grimm begged his friend to return.

The 1931 Chicago American Giants

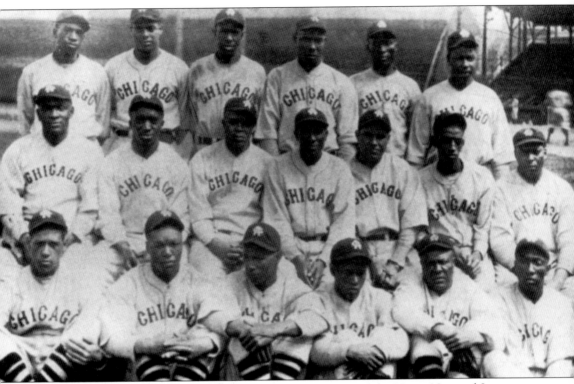

This is a team picture of the 1931 Chicago American Giants of the Negro National League. The American Giants, led by Hall of Famer Rube Foster, were a fixture atop of the Negro National League throughout the 1920s, winning the Pennant in 1920, '21, '22, '26, and '27. Notable Negro League stars on the American Giant teams include Foster's brother, Willie Foster, Hall of Famer Turkey Stearnes, and Alec Radcliffe, brother of Double Duty Radcliffe, the oldest living former Negro League player.

The 1929 Cubs

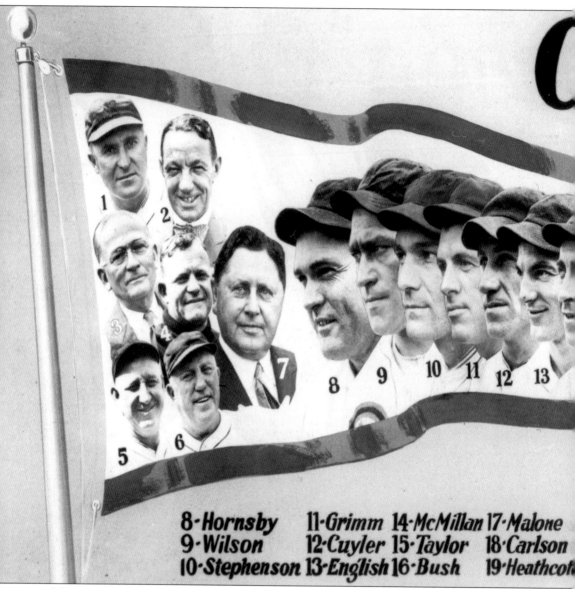

8·Hornsby 11·Grimm 14·McMillan 17·Malone
9·Wilson 12·Cuyler 15·Taylor 18·Carlson
10·Stephenson 13·English 16·Bush 19·Heathcot

Manager Joe McCarthy's pennant-winning 1929 Cubs featured Hall of Famers Rogers Hornsby, Kiki Cuyler, and Hack Wilson. The team finished 98-54, nine and a half games ahead of the Pittsburgh Pirates. Rogers Hornsby hit .380 with 40 home runs and 149 RBI. Wilson, not to be outdone, hit .345 with 39 home runs and a National League leading 159 RBIs. Riggs Stephenson (.362) and Kiki Cuyler (.360) also pitched in to spark this potent line up. Pitchers Charlie Root (19-6) and Pat Malone (22-10) led a solid pitching staff. The team lost a heart breaking World Series, four games to two, to the Connie Mack led Philadelphia A's. The A's

icago "Cubs"

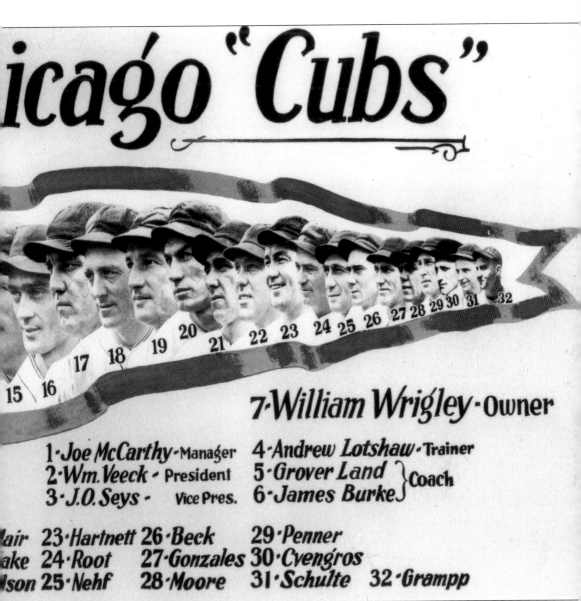

15 16 17 18 19 20 21 22 23 24 25 26 27 28 29 30 31 32

7·William Wrigley·Owner

1·Joe McCarthy·Manager 4·Andrew Lotshaw·Trainer
2·Wm. Veeck·President 5·Grover Land ⎱Coach
3·J.O. Seys·Vice Pres. 6·James Burke ⎰

...air 23·Hartnett 26·Beck 29·Penner
...ake 24·Root 27·Gonzales 30·Cvengros
...lson 25·Nehf 28·Moore 31·Schulte 32·Grampp

were stocked with stars like Al Simmons, Mickey Cochrane, Jimmy Foxx, and Lefty Grove. The Cubs trailed two games to one, going into Game Four, and jumped out to a huge 8-0 lead. They led by the same score going into the seventh inning. The A's woke up and pounded out a record 10 runs in the inning, aided by two fly balls Hack Wilson lost in the sun. The A's won, 10-8, to take a 3-1 Series lead. In Game Five, the Cubs were ahead 2-0 in the bottom of the ninth when the A's scored three runs to take the game, 3-2, and the Series four games to one.

Henry John "Zeke" Bonura
Career 1934–1940 Chicago 1934–1937

"Banana Nose" was a career .307 hitter. The big hitter hit 27 home runs and 86 RBIs, posting a .302 bating average as a rookie in 1934. Zeke also hit .330 with 120 RBIs in 1936. He had another good year in 1937, when he hit .345 with 41 doubles, 19 homers, and 79 RBI. Bonura was a manager's dilemma. He could hit, but wouldn't field. He led the league in fewest errors, mostly by not trying for the ball. His rusty gate fielding, his hold outs, and his supposed affair with a girl whose last name was Comiskey, conspired to chase Bonura out of town very quickly.

Philip Joseph "Phil" Cavarretta
Career 1934–1955 Chicago 1934–1953, 1954–1955

Phil was a career .293 hitter. Cavarretta played on three Cubs World Series teams (1935, 1938, and 1945) and hit a career .317 for the Series. Phil led the National League in hitting in 1945 with a .355 average, winning the MVP. Cavarretta attended Lane Tech, less than two miles from Wrigley Field, and was 18 years old when they called him up in September of 1934.

Joseph Franklin "Frank" Demaree
Career 1932–1944 Chicago 1932–1938

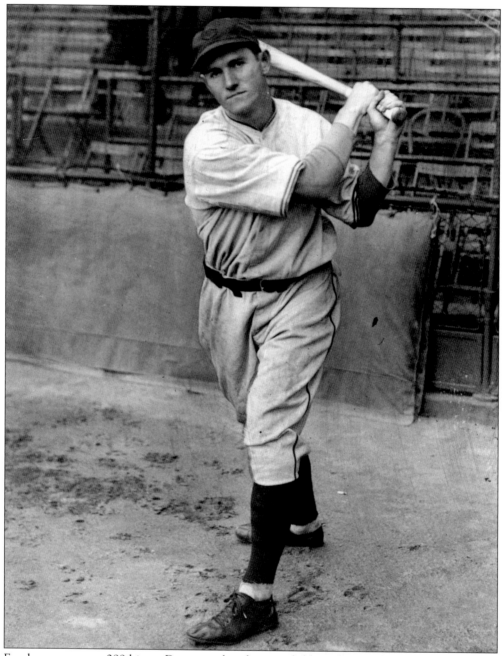

Frank was a career .299 hitter. Demaree played center field on three Cubs World Series teams (1932, 1935, and 1938). Demaree hit .325 in 1935, .350 in 1936, and .324 in 1937. Frank had 16 homers and 96 RBIs in 1936, and 17 homers and 115 RBIs in 1937. Demaree hit two home runs in the 1935 World Series.

HENRY EDWARD "HANK" LEIBER
CAREER 1933–1942 CHICAGO 1939–1941

RAYMOND ALLEN "RIP" RADCLIFF
CAREER 1934–1943 CHICAGO 1934–39

Hank was a career .288 hitter. Leiber hit .310 with 24 homers and 88 RBIs in 1939. He followed that up with a .302 average, 17 home runs, and 86 RBIs in 1940. Hank Leiber had his career cut short in 1941 because of a head injury occurring in the dugout off of the bat of team-mate Stan Hack. Leiber pitched a complete game loss for the Giants in 1942—as an outfielder.

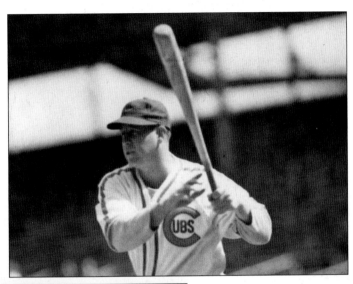

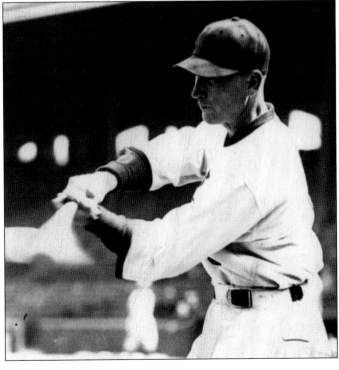

Rip was a career .311 hitter. A rookie at 28 years old, Rip put together three great seasons in a row (1936–1938). In 1936, Radcliff hit .335 with 31 doubles and 82 RBIS. He followed that year up with almost identical numbers for the next two seasons: .325 in 1937 with 38 doubles and 79 RBIs, and a .330 average in 1938 with 23 doubles and 81 RBIs. Once World War II called, his career was over.

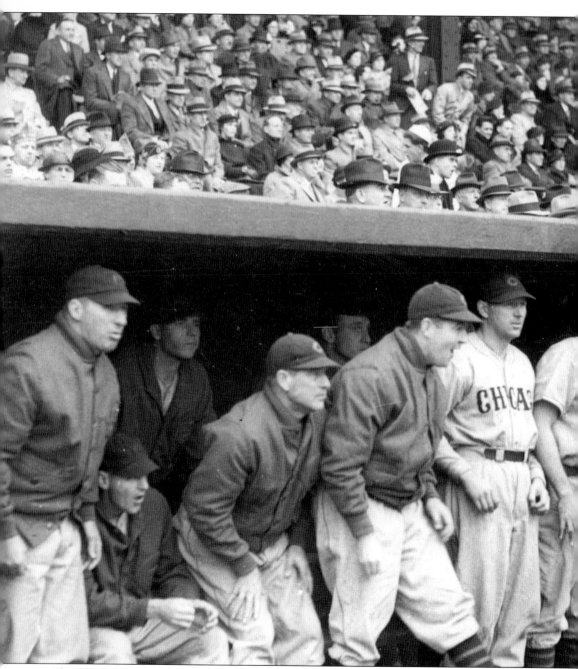

The Charlie Grimm led Cubs rallied to win 21 games in a row at the end of the season to pass the St. Louis "Gashouse Gang" for the National League Pennant. The Cubs finished 100-54, four games ahead of the Cards. They had five .300 hitters on the team, led by Hall of Fame catcher Gabby Hartnett (.344), Hall of Fame second baseman Billy Herman (.341), center fielder Frank Demaree (.325), left fielder Augie Galan (.314), and third baseman Stan Hack

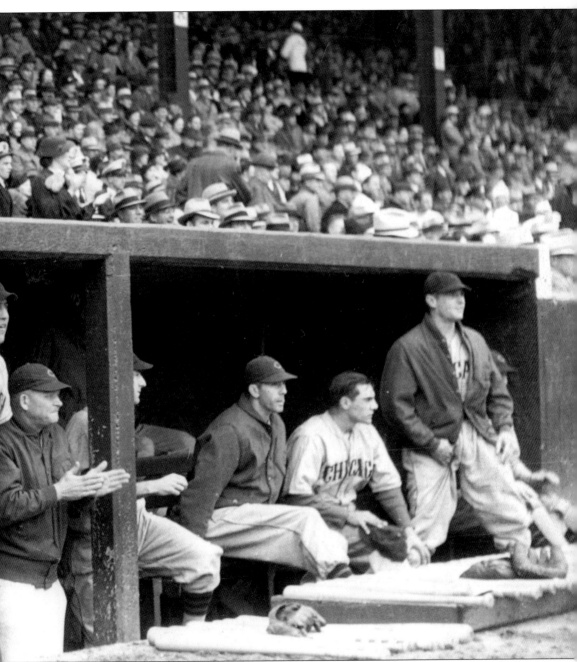

(.311). Pitchers Lon Warneke (20-13) and Bill Lee (20-6) led the strong staff. The big bats were stifled by the Tigers' Tommy Bridges and Schoolboy Rowe, beating the Cubs in the World Series, four games to two. Lon Warneke went 2-0 with a 0.54 ERA. Augie Galan and Hall of Famer Chuck Klein both hit .333 in pacing the Cubs.

Michael "Mike" Tresh
Career 1938–1949 Chicago 1938–1948

Mike was a career .249 hitter. Tresh had a nicely productive 1940 season when he hit .281 and drove in 64 runs. Mike had two career home runs that happened eight years apart, 1940 and 1948..

William Beck "Swish" Nicholson
Career 1936–1953 Chicago 1939–1948.

Swish was a career .268 hitter. Bill played on 1945 Pennant winner. Nicholson led the league in home runs and RBIs in 1943 (29, 128) and 1944 (33, 122). Fans would yell "Swish" when Nicholson took his powerful swing, often hitting home runs, but usually missing. Nicholson led the league in strikeouts or was near the top almost every year.

GLEN DAVID "RIP" RUSSELL
CAREER 1939–1947 CHICAGO 1939–42

After a promising rookie season, batting at a .273 average with 24 doubles, 9 homers, and 79 RBIs, Russell became ill in 1940 and never came close to those numbers again.

LOUIE ALEXANDER "LOU" NOVIKOFF
CAREER 1941–1946 CHICAGO 1941–1944

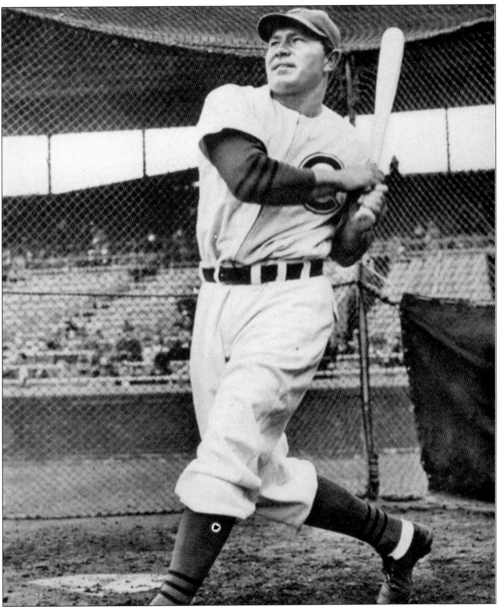

"The Mad Russian" hit .300 in 1942 with 25 doubles. Novikoff was the 1939 Sporting News Player of the Year. Lou could hit, but was brutal in the outfield. He was described as wrestling the ball out of the air and onto the ground, when he caught fly balls. He was a Cub wartime fill-in, and was a character. Novikoff refused to go past the warning track for fly balls, fearing that the Wrigley Field ivy was actually poison ivy. The Mad Russian once stole third with the bases loaded. "I got such a good jump on the pitcher," he was quoted as saying. Lou played softball until he was 53 and is in the Softball Hall of Fame.

Andrew Pafko
Career 1943–1959 Chicago 1943–1951

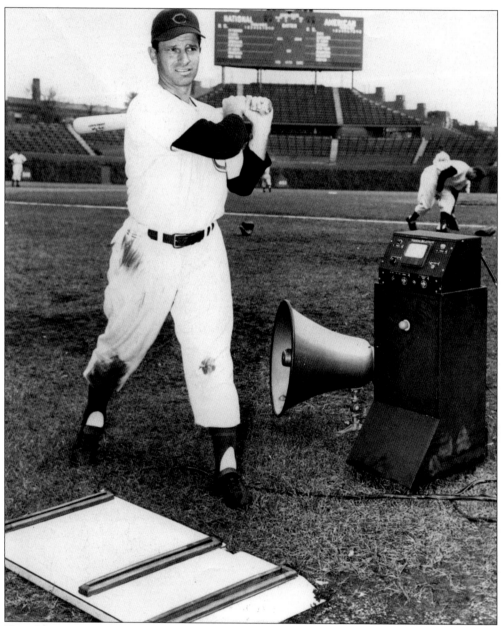

"Pruschka" was a career .285 hitter. "Handy Andy" hit .288 with 24 doubles, 12 triples, 12 homers, and 110 RBIs for 1945 pennant winners. Pafko also hit .312 with 26 homers and 101 RBIs for the 1948 Cubs. Pafko went on to play in the 1952 Series with Brooklyn and the 1957 and 1958 Series with the Milwaukee Braves pennant winners. Handy Andy was very popular in Chicago, and the fans were very vocal in their displeasure at his being traded in 1951 to the Dodgers.

DAVID EARL PHILLEY
CAREER 1941–1962 CHICAGO 1941, 1946–1951, 1956–57

Philley was a .270 lifetime hitter over his 20-year career. He played with the Sox in the early part of his career. In 1949, he hit .286 with 20 doubles and 84 runs scored. Philley was the third piece of the puzzle that brought Minnie Minoso to Chicago in 1951. Philley became known as an excellent pinch-hitter for the Philadelphia in the late 1950s.

HENRY JOHN "HANK" SAUER
CAREER 1941–1959 CHICAGO 1949–1955

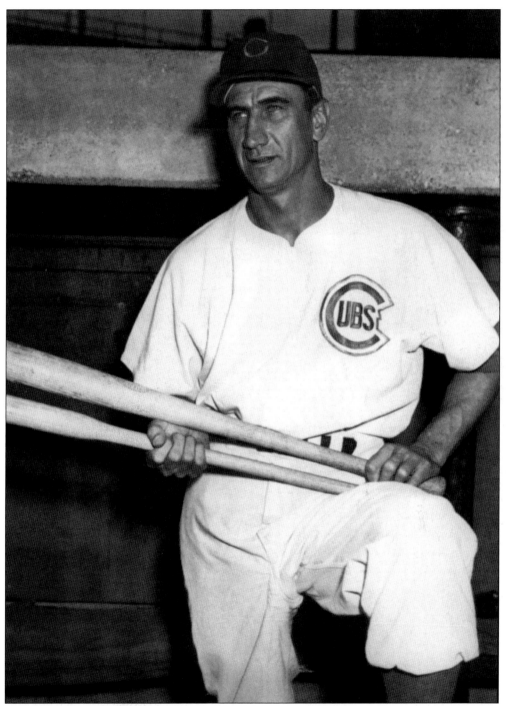

Hank was .266 lifetime hitter. Sauer, 1952 NL MVP, led the league that season with 37 home runs and 121 RBIs, while hitting .270. He also hit .288 with 41 home runs and 103 RBIs for the 1954 Cubs. Sauer didn't reach the majors until he was 31 years old in 1948. The Reds traded him to the Cubs after a slow start in following up to his strong rookie season in Cincinnati. Sauer hit 11 home runs in his first month as a Cub.

Jacob Nelson "Nellie" Fox
Career 1947–1965 Chicago 1950–1963

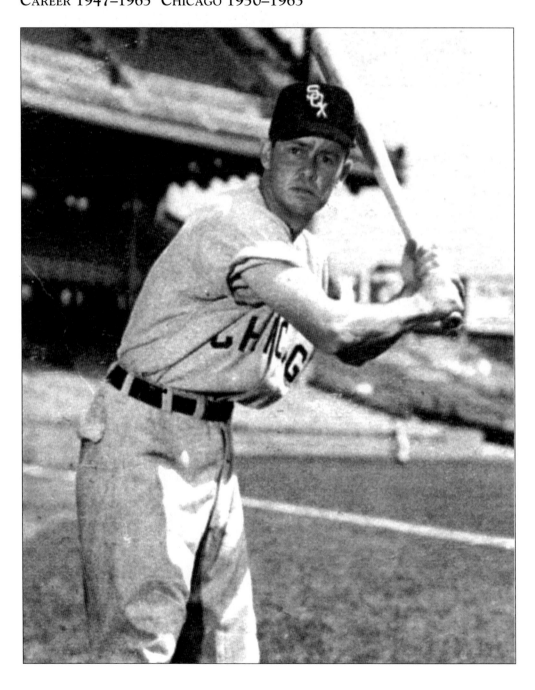

Nellie played second base on the 1959 Sox World Series team. Fox was a career .288 hitter. He led the AL in hits in 1952 with 192, 1954 with 201, 1957 with 196, and 1958 with 187. Fox also led league in triples (10) in 1960. Nellie scored 100 runs or more from 1954 to 1957. Fox hit .375 in his only World Series appearance in 1959. Fox was known for his tobacco chewing which led to his early death from cancer of the mouth in 1975 at the age of 48. He was elected to the Hall of Fame in 1997.

MINNIE MINOSO

CAREER 1949–1980 CHICAGO 1951–1957, 1960–1961, 1964, 1976, 1980

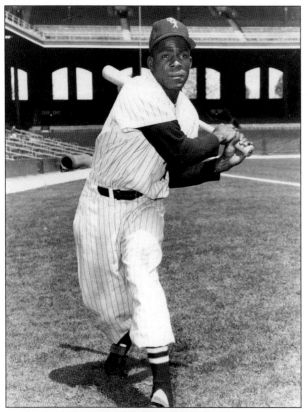

Minoso (left and below left) was a rookie when the Sox obtained him in 1951. The young Cuban ballplayer became the first black player for the White Sox. He missed the 1959 pennant-winning team after being traded to the Cleveland Indians. He was given a ring by Veeck for the pennant, anyway. Minoso was activated by the Sox, as a DH, when he was a coach in 1976 and got his last hit at 53 years old. He was activated again in 1980 and went hitless in his pinch-hitting role. He and Nick Altrock are the only players in major league history to play in five decades. In 1993, Minoso pinch hit for the St. Paul Saints and grounded out to the pitcher at 70 years old.

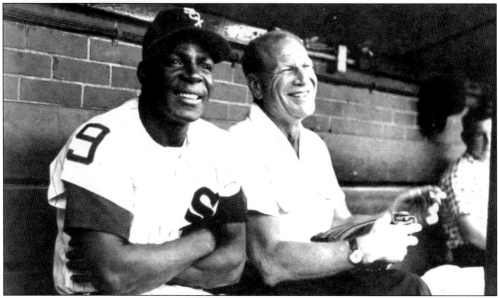

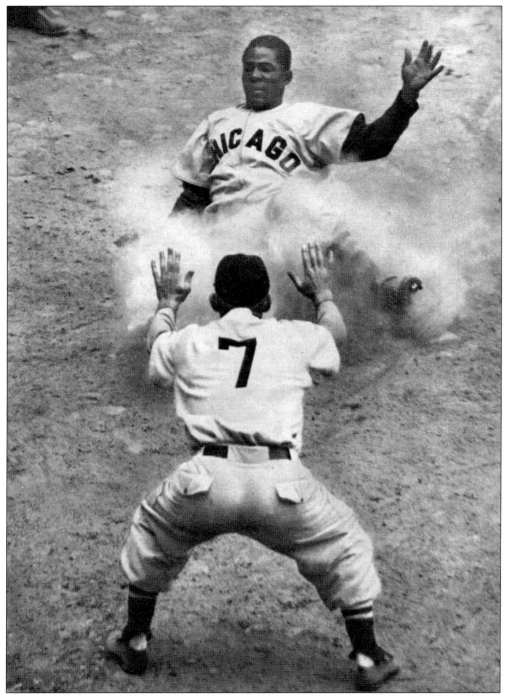

Minnie was a career .299 hitter. Minoso led the league in triples in 1954 (18) and 1956 (11). He also led the league with stolen bases in 1951 (31), '52 (22), and '53 (25). Minnie hit .320 with 18 triples, 19 homers, and 116 RBIs in 1954, the best year of his career.

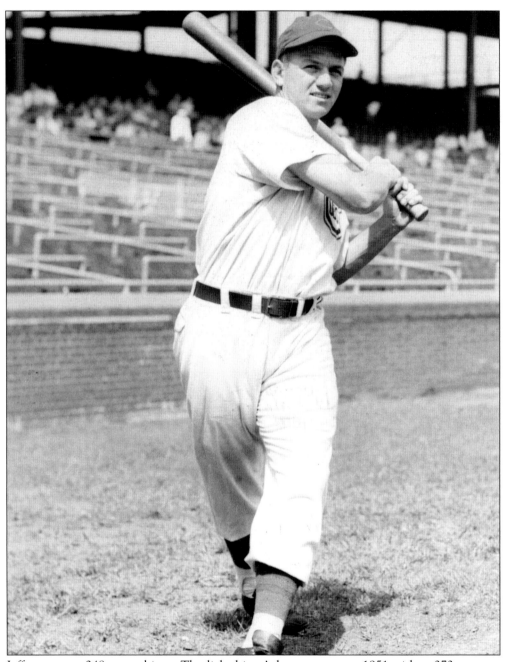

Jeffcoat was a .248 career hitter. The light hitter's best season was 1951 with a .273 average. The interesting thing about Jeffcoat is that he was one of the last players to start his career as a position player and finish it as a pitcher. It usually happened the other way, once a pitcher's arm was done, he'd become an outfielder.

"RUBE" WALKER
CAREER 1948–1958 CHICAGO 1948–1951

Walker had a long career as a platooned catcher that started with the Cubs, mostly known as a defensive catcher. Walker hit .229 for his career. His best season was his rookie year with the Cubs, batting .275. Rube Walker was the catcher for the 1951 Dodgers playoff team after being traded by the Cubs. He replaced an injured Roy Campanella in Game Two against the Giants and caught Clem Labine's two-hitter. Walker hit a two-run homer in the game. Rube was also the catcher for Ralph Branca when Bobby Thomson hit his "Shot Heard 'Round the World."

GUS EDWARD ZERNIAL
CAREER 1949–1959 CHICAGO 1949–1951

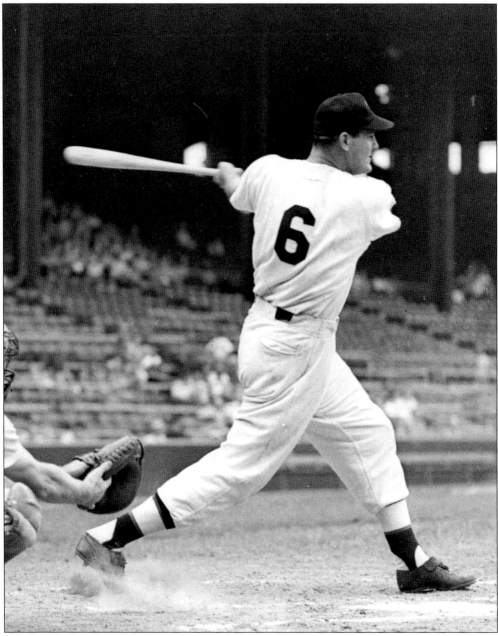

"Ozark Ike" was a big hitter who started his career with the Sox. In his first full season, 1950, Zernial hit .280 with 29 home runs and 93 RBIs. They traded him in 1951 to the A's after the fourth game and Zernial went on to the lead the league in home runs (33) and RBIs (129). Zernial was an All-star in 1953 with the A's, and he was the third cog in a trade that brought Minnie Minoso to Chicago.